The Fundamentals of Drawing

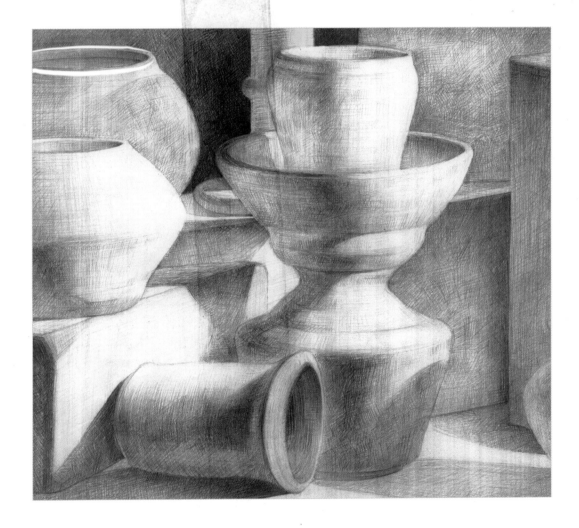

*This book is dedicated to my wonderful wife and muse, Rie, and to all of the
talented and dedicated students I have had over the years;
this book would not have been possible without them.*

JIM DOWDALLS

www.walterfoster.com
3 Wrigley, Suite A
Irvine, CA 92618

Publisher: Rebecca J. Razo
Creative Director: Shelley Baugh
Project Editor: Stephanie Meissner
Managing Editor: Karen Julian
Associate Editor: Jennifer Gaudet
Assistant Editor: Janessa Osle
Production Designers: Debbie Aiken, Amanda Tannen
Production Manager: Nicole Szawlowski
Production Coordinator: Lawrence Marquez

Printed in China
1 3 5 7 9 10 8 6 4 2
18880

Table of Contents

Introduction

The ideas, concepts, and techniques in this book are based on an academic model of drawing instruction developed over the last 500 years, first taught in Europe and now worldwide. These traditional principles are alive and well wherever there is a desire to impart formal fundamental and foundational instruction in realistic, accurate artistic interpretation.

What I seek to impart in this book to the serious, but beginning, drawing student is a solid foundation that leads to the creation of artwork that combines strong draftsmanship, spatial comprehension, and an overall energetic drawing experience.

The most important aspects of successful drawing are sensitivity, focus, and passion. We are all born with the ability to create; in some children this ability is nurtured, while in others it may be repressed. As adults, we still have the ability to "tap into" our creative side, but it takes practice, patience, and guidance.

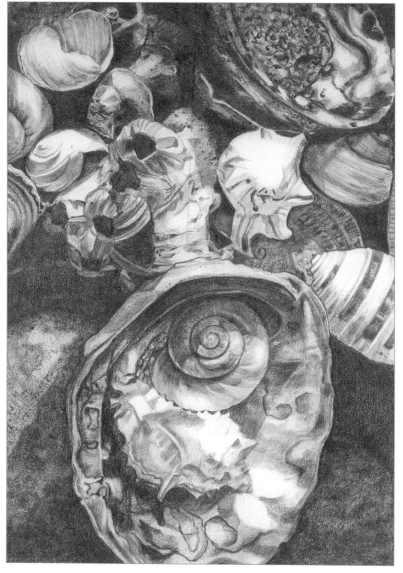

Student drawing by Joanna Mendoza.

Sensitivity

Sensitivity in drawing refers to the handling of tools, as well as the ability to use visual sense to isolate the structure, organization, and mood of a subject. By manipulating the pressure of a drawing tool on paper, the artist can create multitudes of variable line weights: long lines; short, choppy strokes; bold calligraphic marks; and nuanced, subtle tonalities. This is called "mark-making," and most of us have been doing it since before we could talk or walk. With direction, mark-making can be refined to the point where recognizable subject matter can be created. But it is important to note that all marks are not created equal! One of the most important attributes of a successful drawing is a sensitive application of varied line weight.

Focus

In drawing, focus refers to the ability to concentrate on and develop a clear image of the subject. In this book, the emphasis is on drawing a realistic, or representational, interpretation of the subject from observation. It is about attempting to depict a three-dimensional form on a two-dimensional surface. This is a visual alchemy that artists have struggled to achieve since the days of the first cave paintings. Focus is an essential skill that can be achieved with patience, practice, and the right environment. For me, it is the right combination of silence and/or background music (classical in my case) that can help create this focused environment. Most importantly, try to clear your mind of clutter and negative thoughts, and avoid undue visual or aural distractions.

Passion

Passion in drawing, as in life, is the desire for something meaningful that can fulfill, entertain, heal, and ultimately satisfy the creative impulse. You can attain sensitivity and focus, but without the third leg of the stool—passion—you won't have the desire to draw all the time. And that is what makes a successful artist—drawing tirelessly, constantly, and happily, over and over again.

Getting Started

In this book, I will take you through a journey of many steps, some easy and some challenging, as we continue along a path that will establish a strong foundation for the fundamentals of drawing. It is my goal to inform, motivate, and inspire you every step of the way along this new creative journey.

Process & Procedure

In this initial chapter, we will explore the arrangement of the drawing surface for maximum effectiveness, how holding a pencil can make a difference in the way a drawing looks, how making marks on a drawing surface can represent a dimensional reality, and how to successfully build a drawing from the understanding and use of a few key fundamental steps.

Remember: A long journey begins with small steps.

Drawing & Viewing Arrangement

The ideal way to see a subject and the drawing surface simultaneously is to elevate the drawing surface as vertically as possible, while maintaining a comfortable and accessible drawing position. The artist's eyes should be the only things that move, back and forth or up and down, from the subject to the paper. The more a drawing surface is angled away from the artist's line of sight, the less the artist will be able to comfortably view the subject. Working at an easel is an advantageous position for a variety of reasons. Most importantly, the less the artist has to move his or her head the better.

An easel allows the artist to simultaneously face the paper and the subject while drawing. Set up the easel slightly to one side of the subject so that you can see it as well as the paper with a slight back-and-forth motion of the eyes. Another advantage is the ability to more easily step back from the easel to critically evaluate the process.

You may also choose to use a drawing table, which can be elevated to a height similar to the viewing situation an easel would provide. Elevate the table as close to a 90-degree viewing angle as possible, while still being able to see the subject over the elevated table edge.

Holding the Pencil

There are two ways to hold a pencil while drawing. The first is the basic overhand, or "handwriting," position. The pencil sits in the crook between the thumb and first finger, with the palm of the hand parallel to the paper. Most people instinctively hold a pencil this way because it is comfortable and how we are typically taught to write. This is a good way to hold the pencil if you are working on detail and want more control.

The second way to hold a pencil is in the "underhand" position. The pencil sits comfortably in the palm of the hand, with the barrel balanced and supported by the thumb and the first and second fingers. There are several variations of this position. The palm may be placed parallel to the paper or at a right angle to the paper's surface. The pencil may be gripped at the point for more control or further up the pencil barrel for more expressive mark-making.

Overhand

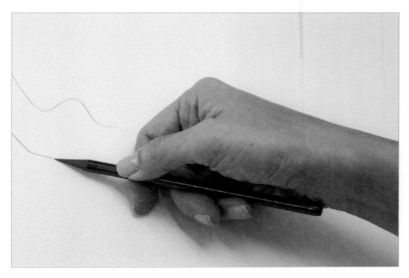
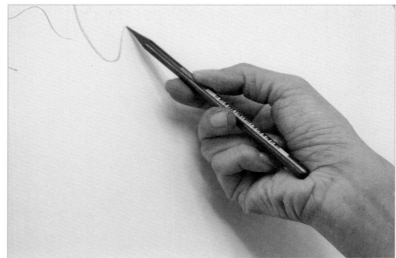

Underhand

Mark-making

The idea of making a mark to record an interpretation of an object is, and has always been, a primary goal of humanity across all cultures. All representational drawing is based on this abstract concept: the accumulation of marks or lines meant to represent reality. Marks can also be purely ornamental or nonrepresentational, but here we refer to mark-making as a method that leads to a perception of reality and an understanding of a subject. Mark-making can be as varied as the tools used to make it.

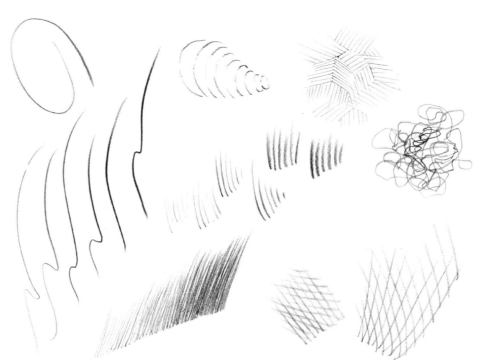

Line Weight

The weight of a line refers to the lightness or darkness of the line based on how much pressure the artist chooses to apply with his or her pencil. A weighted, or variable, line weight is much livelier and more interesting than a line that remains consistently the same. Imagine a lilting delivery of a Shakespeare soliloquy by an accomplished actor, and then compare it with a flat, monotone approach.

Line weight and variety in a drawing can convey texture, weight, and lighting on the surface of a form. It can also serve to focus the viewer's eye on a certain part of the drawing—strong line weight draws the eye more than weak line weight. This is helpful in demonstrating visual hierarchy, when one object is in front of another.

Variable line weight can be used to lead a viewer through the journey of a drawing, creating a dialogue between the artist and the viewer.

Gesture Drawing & Contour Line Drawing

Gesture drawing and contour line drawing are two opposite approaches to the drawing process; however, they can be used together. Gesture drawing is a very quick, all-encompassing glimpse of the subject. Contour line drawing is a slow, methodical, detailed observation of the subject. When used together, these two differing approaches to drawing the subject can become the foundation for a successful drawing.

Gesture Drawing

A gesture drawing conveys an interpretation of the subject through continuously flowing, rhythmic line, without any sense of detail or refinement. Drawing in this manner can be used to warm up your hand, like exercising. A gesture drawing can also act as a preliminary sketch for a more detailed drawing. This method employs continuous movement of the arm and hand without lifting the pencil off the paper or using short, choppy lines or strokes. Imagine that the pencil is actually on the form itself and not merely touching the paper. This takes practice and patience to do well, but it is very much worth the effort.

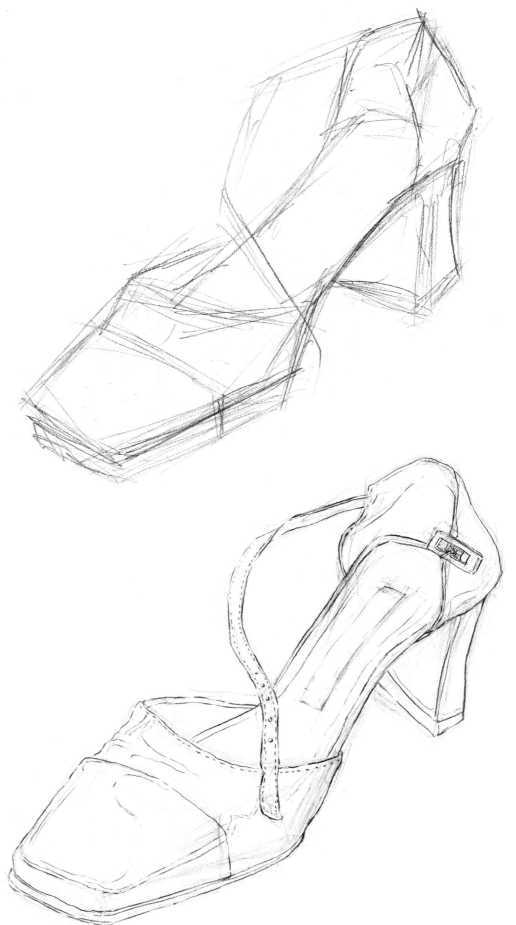

Contour Line Drawing

Contour line drawing is a detailed interpretation of the subject matter, without employing tone or shading. This type of drawing is not just a simple outline of the outer edges of a subject, however, which would give the impression only of a flat shape or silhouette. Dimensionality is achieved through a careful investigation of all inner and outer "touchable" edges. To develop and implement the sensitivity and skill that this type of drawing requires, the eye and the drawing hand should travel around the form of the subject at a slow, searching pace, without hurried sketching.

Blind Contour Line Drawing

Blind contour line drawing is a valuable exercise in learning and refining your observational skills. Drawing a subject on paper without looking at the paper while you draw involves a careful approach to observation and good hand-eye coordination. Start drawing anywhere on the form, and imagine that the tip of the pencil is touching the actual form. As you move the pencil slowly around the form in a continuous line, only look at the subject, not the paper. You may stop at any time and glance at the paper to relocate your pencil on the form, but don't start drawing again until you are looking only at the subject.

Cross-contour Drawing

Cross-contour drawing is an effective technique that conveys the feeling of a three-dimensional form on a two-dimensional surface. This technique builds on contour drawing by describing the mass and volume of an object, in addition to its shape.

This technique employs sensitive line application, including variable weight lines across the entire surface of a subject, not just the touchable edges. This continuous line application is ideal for conveying the variations inherent in natural, organic forms.

To understand how to start this type of drawing, think of a basic three-dimensional geometric form, such as a sphere, and understand how horizontal and vertical lines would look across it's surface. As these parallel lines move toward the tops and sides of the sphere, notice how they appear closer together until they almost converge. This is known as *foreshortening*.

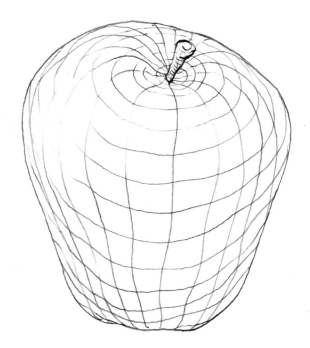

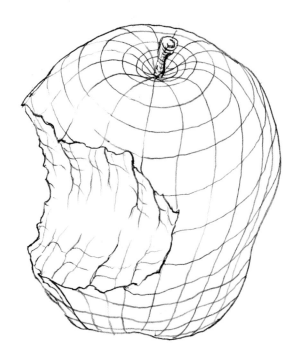

Applying this technique to a more organic shape, such as an apple, demonstrates how this type of mark-making shows the exterior shape of an apple as well as the subtle variations within the form. Imagine wrapping a string or wire around the form to represent drawn lines as they would appear on the object's surface.

To create even more three-dimensionality and a sense of volume, use a variable weight line across the form's surface, which can elicit a feeling of depth (nearness or distance from the viewer), as darker lines tend to come forward and lighter lines tend to recede. This is also an effective way to show the effects of light on the form, as lighter lines suggest areas facing a light source and darker lines suggest those in shadow.

Foreshortened Forms

When an elongated subject, such as a shoe, is viewed at a certain angle (sometimes called "straight on"), the overall length of the subject seems much smaller, or shorter in length, than we actually know it to be. This is the result of compression of space within the form. This compression is best explained by the overlapping of forms in a "foreshortened" manner. We will discuss this more thoroughly in the following chapter on perspective and its applications.

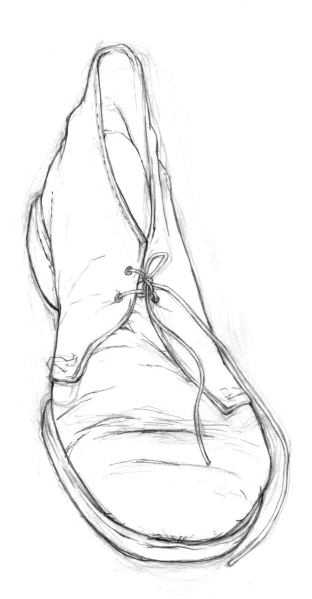

Additional Considerations

Shapes

An important aspect of the initial gesture block-in sketch is to always start with the basic geometric shapes that most resemble the form or forms you see. The most common shapes found within most forms, either organic or man-made, are the square, sphere, cylinder, and cone.

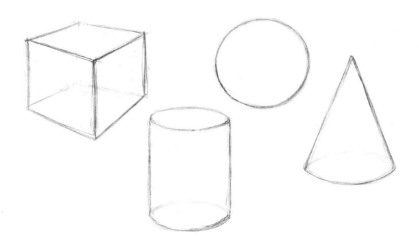

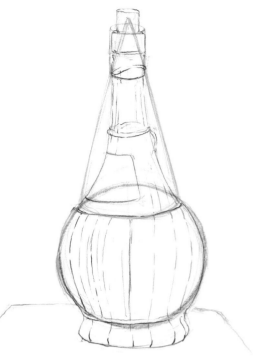

Sketch these forms lightly and loosely in a transparent manner first, so that it becomes apparent how much depth or volume each object contains.

Overlapping Objects

When combining multiple objects in a small composition, start with a gesture drawing of the furthermost object. As the objects advance toward you and overlap each other, sketch them in loosely and lightly over the object behind it. If you sketch each object's initial shape, each object retains its own three-dimensional space or volume (also called its "footprint").

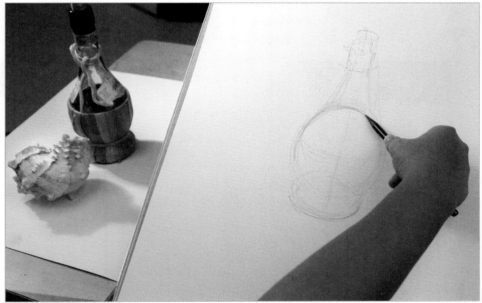

When you are finished with the blocked-in gesture sketch, complete a contour line drawing over the light gesture sketch of the object that is closest to you in the foreground. This method allows you to maintain control over overlapping shapes. Finish the contour line drawing for the nearest object before you start on the object behind it so that you don't cross over a line or form that is meant to be in front of the furthermost object.

Putting It All Together

By using all of these techniques in one form or another, you will see a marked improvement in your drawings, both in appearance and accuracy. In order to combine gesture and contour line effectively, follow these quick tips:

- Start with a quick, light gesture sketch that provides the correct size, proportion, structure, and placement on the page. Remember, if the underlying gesture sketch is too detailed or dark, the subsequent contour line drawing will appear redundant and self-conscious.

- Next apply a "finishing" layer of contour line that is more detailed and that engages the viewer with interesting and expressive line quality and variety.

- Use a light graphite pencil, such as an H or F, for the initial gesture sketch and a darker graphite pencil, such as a B, 2B, or 4B, for the contour line. (See Chapter 2 for more details about pencil grades.)

YOUR HOMEWORK

For your first homework assignment, we will focus on some of the most important areas of study in this chapter. Pick subject matter that interests you, but is organic in nature—inherently simple in shape and form—and presents an opportunity to draw contours inside the form, as well as outer contour edges. This type of seashell is a perfect example.

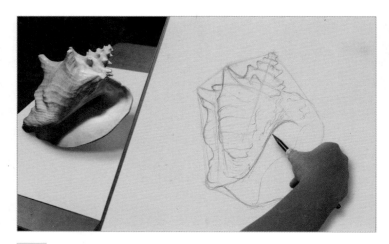

1 Use an H or HB pencil to develop a quick gesture sketch of the object, taking no more than 2 to 3 minutes to block in the entire structure. Don't worry about details or dark lines.

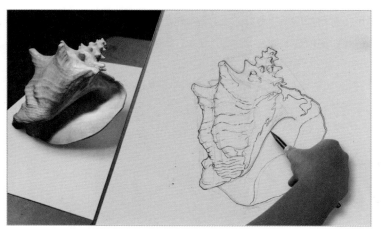

2 Slow down, and draw a weighted contour line drawing over the gesture. Take your time; spend 20 to 30 minutes on this part of the exercise. Remember to contour draw all of the touchable edges of the form, not just the outside contours. See how much information you can give the viewer about your chosen subject matter, without resorting to shading. Use B and/or 2B graphite pencils for the finishing contour.

Materials

There is a whole host of drawing media available, from graphite and colored pencils to charcoal, crayon, and pastel. The myriad tools can yield smooth tones, expressive strokes, dramatic monochromatic palettes, and richly colorful pieces. This chapter covers a variety of drawing materials available to artists, arming you with the information you need to get started in using and mastering the tools. There is a wide range of high-quality materials available at art & craft stores or other art suppliers, and each artist has his or her own preferences. Experiment with different brands and types of materials to discover which ones you prefer.

Graphite Pencils

Graphite pencils come in a range of values, starting with 9H lead as the lightest (or hardest) and graduating through a succession of pencils to 9B, which is usually considered the darkest (or softest). Some manufacturers carry grade EB and EEB for "extra black" and "extra extra black." HB and F graphite pencils are positioned as the middle-range value.

Leads can also be purchased without a protective wood or plastic cover; these leads can be used with a separate holder, usually retractable, that is made of metal or plastic. They can be sharpened with their own "lead pointer" or on a sandpaper pad.

A carpenter's pencil is a flat and wide variation on the graphite pencil. They are available in a limited range of values.

◄ Graphite sticks are available in a narrow range of values (usually only B and 2B), but can be very useful for large, loose, expressive applications of graphite; these sticks are usually sharpened or chiseled with a sandpaper pad or block.

▼ These graphite pencils represent two different manufacturers' ranges of graphite pencils, including an HB, 2B, 4B, and 6B, from lightest to darkest. The lead holder at the end contains an H grade graphite lead.

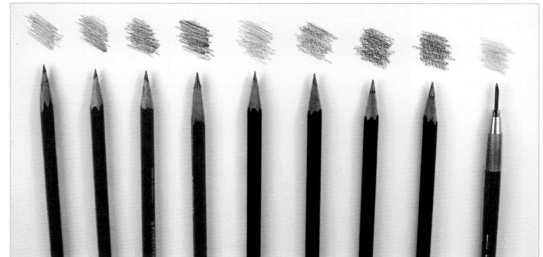

Sharpeners

There is a wide range of pencil sharpeners available for graphite pencils, from the small plastic sharpener most people are familiar with from grade school to a high-end electric motor that gives pencils a beautifully long and tapered point.

Mat knives or hobby knives can also be used to cut away the wooden cover of the pencil, as well as to sharpen the lead's point.

Many artists use sandpaper pads to sharpen various types of art media, including graphite pencils. Sandpaper pads are useful for creating a chiseled tip, which gives an artist the ability to create soft, wide strokes.

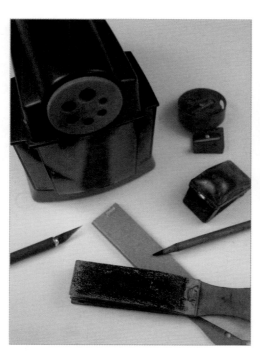

Erasers

Erasers should be considered effective drawing tools, not just something to remove mistakes. They can be used to create light areas and sharp highlights and to subtly alter and vary the value of a flat graphite application.

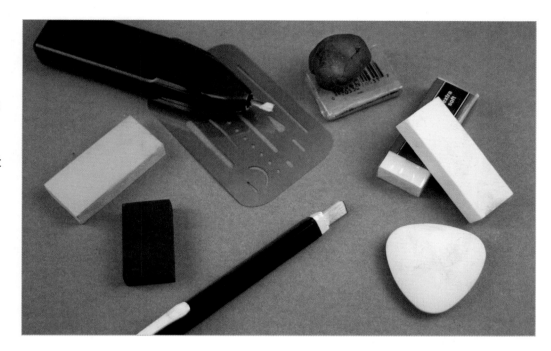

There are many types of erasers, but most are plastic, vinyl, or rubber. Each type has its own characteristics and qualities.

Good options for erasers include white plastic or vinyl erasers and the kneaded eraser, a personal favorite for its ability to be "kneaded" into any shape, even a point. This eraser does not leave residue or crumbs behind.

Stick erasers are functional for erasing small, precise areas of graphite and can be chiseled with a knife for even more accurate erasing.

Electric erasers are another option for removing small areas of graphite, particularly in the creation of highly-lit sharp edges on a form, as well as small highlights on reflective surfaces.

Charcoal

Charcoal is created by slow-burning wood in the absence of oxygen in order to create carbon. This carbon residue is mixed with binders to create sticks and pencils. There are many varieties of charcoal media, but they can usually be separated into these categories: *vine charcoal, compressed charcoal,* and *charcoal pencils.*

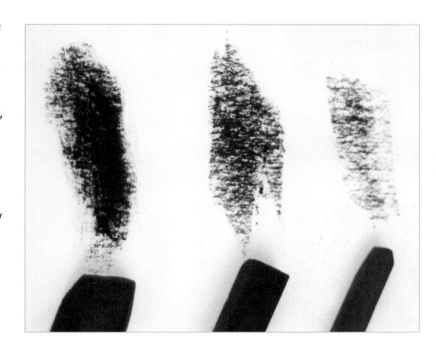

Vine charcoal is typically made from burned grapevine and tree branches, usually willow. Willow charcoal and vine charcoal have very similar qualities; they are usually very soft and light when applied to paper and can easily be blended and lightened with a kneaded eraser or chamois. Both come in hard, medium, or soft grades.

Compressed charcoal is charcoal or carbon mixed with a gum binder that makes it darker and more permanent than vine or willow charcoal. Compressed charcoal tends to have a velvety matte-black appearance that is much richer than vine or willow.

A charcoal pencil contains a "lead" of compressed charcoal, covered with a wood or plastic sleeve. Some charcoal pencils have a paper outer coating that allows the tip of the pencil to be exposed to as long of a point as desired; these pencils are typically sharped with a knife and sandpaper pad.

White charcoal pencils are actually not charcoal at all, but a combination of chalk and a wax or gum binder. They are very effective when used as the third value with charcoal on toned paper.

Conté Crayons

Conté crayons are available as sticks and pencils. Made of a mixture of graphite and clay, in differing amounts for variations in softness and color, Conté is usually available in black, white, and several varieties of red and brown tones.

There are also several alternatives to Conté pencils, available from different manufacturers, that have similar clay-to-graphite ratios and are either encased in wood barrels or sold in long crayons that fit into specially designed plastic or steel holders.

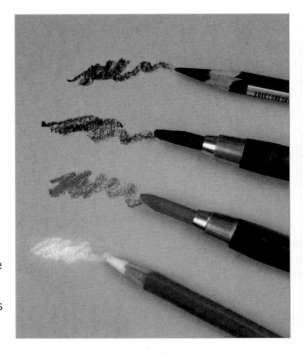

Dipping Pens

Pens are a very traditional way to work with ink; steel and copper pen points are repeatedly dipped into an ink bottle, or other liquid reservoir, to refill the pen. The amount of ink collected on the nib depends on the size of the nib. The thickness of the drawn line depends on the amount of pressure applied, as well as the size of the nib. The smallest pen points carry only as much ink as their surface area allows and must be repeatedly dipped into the ink.

Larger nibs have a two-tiered ink collection system that holds an amount of ink directly above the point; the ink is released as pressure is placed on the paper with the nib. There are different types of large nib tips: flat, round, and square. Each type has several different sizes. My personal favorite for all-purpose drawing is the B (round tip) 5½. These types of drawing nibs allow for a wide range of expressive line weights, along with expressive flourishes similar to what a brush can do.

Ink

Inks have been used for thousands of years, for both written documents and art. Today, inks consist of soluble dyes in a shellac solution and are either water-soluble or waterproof. They are available in a variety of colors, including black. Inks may be mixed with water to create washes with a variety of different values.

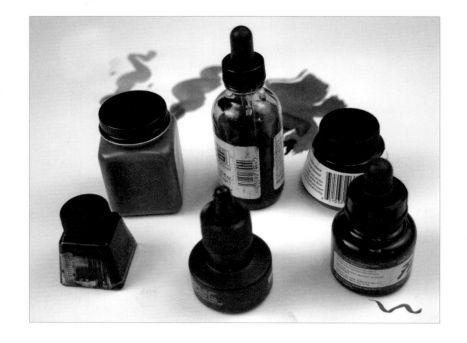

Drawing Pens

Drawing pens provide rich black ink flow in various sizes and widths, but without the variation in line weight that dipping pens allow. They are a clean and simple alternative for sketching and drawing, without the cleanup associated with dipping pens, which must be washed after each use. These pens can be purchased individually or in sets of differing point sizes.

Ink Brushes

Bamboo brushes are the most common type of brush used with ink and ink washes. The shellac in ink can degrade an expensive brush, and bamboo brush fibers are usually blends of inexpensive goat, sheep, or badger hair. These hair fibers can be easily molded into a fine point, and their absorbent nature means they hold a lot of liquid. They come in many sizes, from very small to very wide.

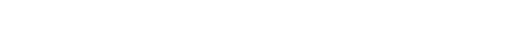

Ink Brush Pens

Ink brush pens are an expressive type of disposable ink pen that come in many different sizes and colors, as well as sets, including black and shades of gray. They are great for more expressive mark-making than a regular ink pen, as well as practical, since they don't need to be cleaned after each use.

Markers

Felt-tip markers come in a variety of colors, sizes, and shapes, including flat, chisel, point, and brush. Most markers are either water- or alcohol-based; markers that contain other types of solvent base should be avoided for health reasons. Markers are versatile for sketching and adding quick tone or color. They are considered a "dry" medium, as they dry quickly upon application. However, markers are not used much in fine art, as their color is fugitive and tends to fade over time. Instead, they are used extensively in commercial art applications, for product and concept sketches and renderings.

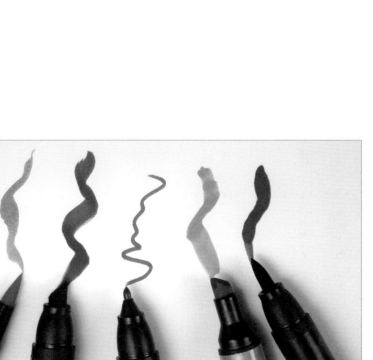

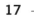

Hard Pastel Pencil

Soft Pastel Stick

Oil Pastel

Pastel

Pastels are powdered pigment compressed into sticks with a gum arabic binder.

Pastel sticks and pencils come in varying degrees of hardness and softness, depending on the proportion of binder to pigment. Softer pastel sticks usually come with a paper wrapper for protection. The most inexpensive "pastels" are usually made of chalk, similar to what is used in a grade-school classroom or on the sidewalk. The pigments are generally weaker and the binders are inferior for good paper-surface adhesion.

Oil pastels have pigment and an oil or wax binder. They feel sticky or waxy to the touch, as opposed to the dryness of a soft pastel. The look of an oil pastel drawing can be similar to that of a soft pastel drawing, but it can also be more layered and less blended. Generally, the more expensive the oil pastel, the more vibrant the color and softer the texture. However, an inexpensive oil pastel set is suitable and affordable for beginners, as the quality does not suffer as much as in soft pastels.

Colored Pencils

Colored pencils consist of wax-based pigments encased in a protective wood cover. They are available in sets from 12 up to 150, depending on the manufacturer. They also vary in hardness and color intensity, depending on the cost, as well as their intended use. Some very hard colored pencils are used primarily for sketching and detail use; therefore they lack the color intensity of a fine-art type of colored pencil. Generally, the softer and more expensive the colored pencil, the more lightfast and brilliant the color.

Papers

Art papers are classified in many different ways depending on their use, surface texture, weight, and other characteristics.

Generally, papers are split into two categories: *cold-pressed* and *hot-pressed*. Hot-pressed paper, also called "plate surface," is the paper of choice for pen and ink drawing, as well as some graphite techniques that call for precise rendering. Cold-pressed paper, which has more surface texture, comes in different grades, including smooth, vellum, and rough. Cold-pressed paper is usually the overall choice for most techniques involving graphite and charcoal.

Drawing papers come in pads of varying sizes, starting around 9" x 12" up to 18" x 24" and are usually labeled as either "sketch" or "drawing" pads. Sketch pads are usually inferior in quality to drawing pads but can be more economical, especially for beginning artists. The least expensive alternative is "newsprint," which I do not recommend, as graphite application on this paper tends to look weaker; these papers are also prone to yellowing and brittleness.

The gold standard for drawing paper is acid-free, 100 percent cotton rag paper, but there are some good alternatives on the market, especially some of the "recycled" cotton drawing pads.

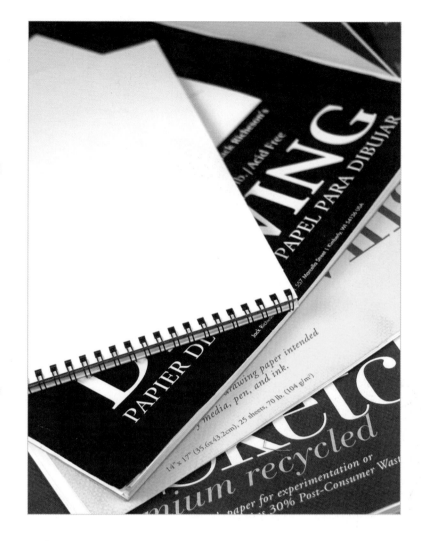

Other Art Papers

Laid papers are quality white or toned papers that have a grid pattern embedded into their surface texture. This texture holds medium well, making the surface very good for soft media, such as charcoal and pastel. There are also many types of printmaking and pastel papers that are quite conducive to all dry media. Pastel papers are usually thicker ply and have a rougher textured surface than traditional drawing papers in order to retain the soft strokes of pastel on the surface.

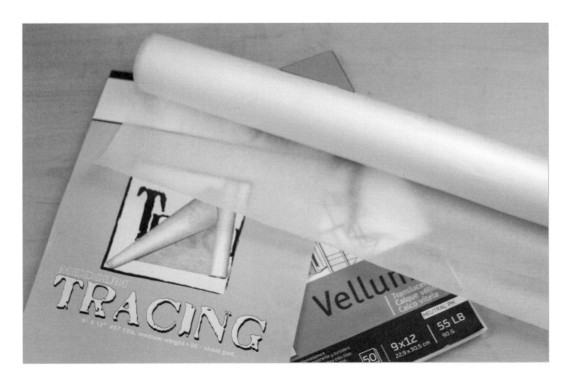

Tracing Paper

Tracing paper, sometimes called "sketch paper" when it comes in a roll, is a translucent lightweight paper used in situations where layers of refined drawings are desirable. Vellum is a thicker-weight translucent tracing paper, which has a surface similar to drawing paper. Most commercial artists use tracing paper and sketch paper, due to their economical and translucent qualities.

Other Materials

Serious drawing students need a few other materials. A drawing board, usually made of wood or Masonite and large enough to accommodate at least 18" x 24" paper, is a necessity. Large brushes come in handy for sweeping away eraser crumbs. You should also have a utility knife for sharpening pencils, different types of rulers, and perhaps a T-square and triangle. If you work with charcoal or pastel, you will need fixative spray to seal your finished art.

Tape

Tape is an important addition to your art supplies; it can hold your drawings to a drawing board and be used to create clean-edge borders around a tonal drawing. Avoid masking tape, which rips most drawing papers. Instead, look for artist tape or drafting tape, both of which are fairly low-tack and will not harm most art papers.

Construction Tools

A viewfinder can be very helpful for composition, but an old slide-holder works just as well. I hand out chopsticks to my students on the first day of class, which come in handy for proportional measurements and for finding angles when dealing with perspective construction.

How We See & Interpret

In the first chapter we concentrated on the simple act of making marks on the page—marks that are intended to represent three-dimensional objects on a flat piece of paper. As we prepare to transition to more difficult and complex subjects, such as still life and architecture, we need to understand and analyze what exactly we see, and how best to apply that scene to the drawing surface. In this chapter, I will demonstrate some simple, yet effective, techniques that artists have employed for hundreds of years that can help the artist organize and understand a complex scene in a logical way. This information on the picture plane—measuring, eye level, and visual spatial interpretation—will be discussed at length throughout the chapters in this book.

Proportion & Size Relationships

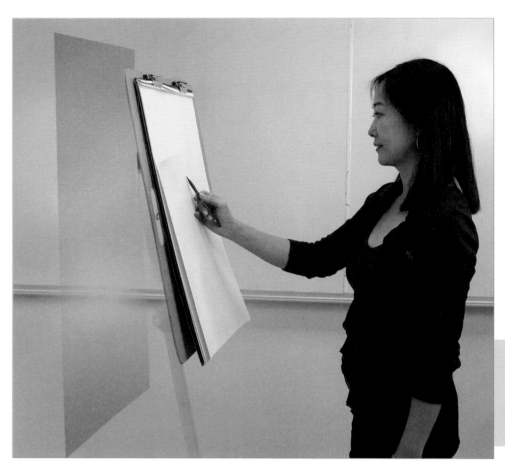

The Picture Plane

In considering the way we see and re-interpret objects in space, the first concept to understand involves the *picture plane*. The picture plane is an imaginary glass window that stands parallel to the viewer (the artist) and between the viewer and the subject. This imaginary plane is meant to represent the flat surface that the artist is drawing on (the paper surface). In an ideal theoretical situation, the artist would be able to trace the subject directly onto the glass window. In reality, there are ways for the artist to make use of this imaginary window to transfer the subjects seen through it onto the paper surface.

Consider the picture plane (blue rectangle) as an imaginary "window" parallel to the drawing surface. We see what we are drawing through this imaginary window.

Space and Depth

When viewing objects sitting on a flat ground plane in close proximity to each other, such as the coffeepots below left, we can easily see that the objects are of similar size. When the far left pot is moved toward the picture plane and the center pot is moved toward the back of the ground plane, there is the illusion of a change in the size of the pots (below right).

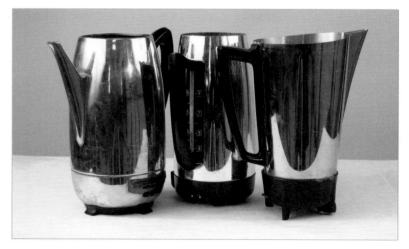

These coffeepots are very close to each other, sitting on the ground plane at about the same horizontal depth, approximately midway from the picture plane to the back of the ground plane.

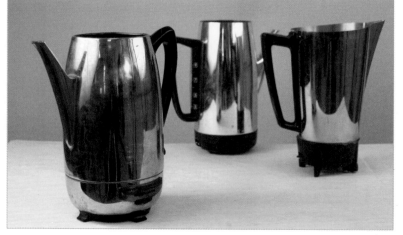

The left pot is now the largest in relation to the other two and is near the bottom of the picture plane. The center pot's base is now the highest of all three within the picture plane. The top rims of all three pots are still relatively level with each other, when viewed horizontally across the picture plane. This relates to how we perceive cylindrical tops that are close to eye level.

As we move the objects around the ground plane, we can see the "changes" that occur in their relative size—though we know that the objects are all physically the same size. This illusion is the result of a visual interpretation called *diminution*, a hierarchy or size relationship caused by an increase in space between the objects, making objects of similar size look smaller as they move away from the picture plane.

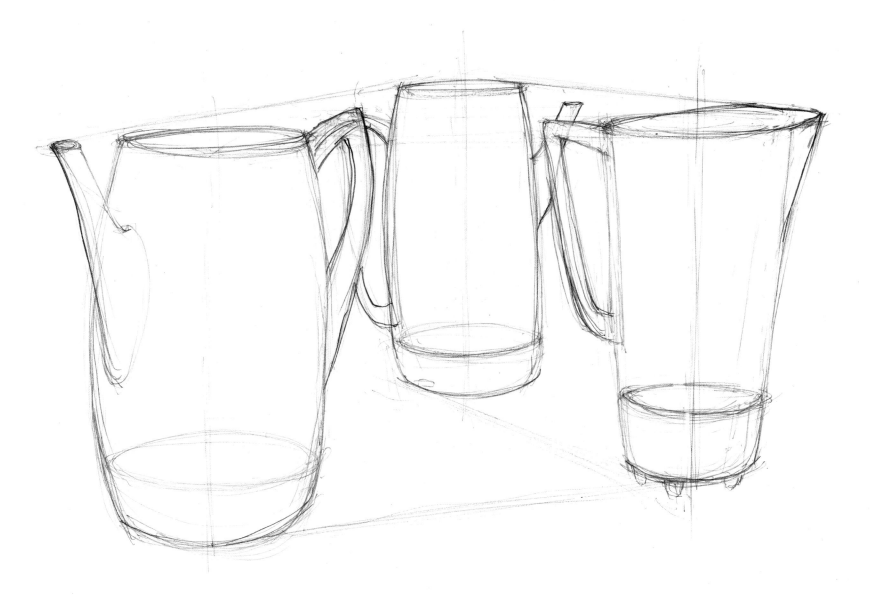

Most people recognize this intuitively, but it is important to note how size diminution appears to the artist through the picture plane. The three coffeepots above are at the artist's eye level. We know this because we can still see the tops of the pots, and even just a bit down into them. As the pots advance toward the viewer, the tops appear lower on the picture plane, but the overall heights appear taller, and the widths seem wider. The pot closest to the viewer is the largest, and its base is the lowest on the picture plane. This consistently happens when objects are viewed from above or below eye level.

Eye Level

Eye level, also called the "horizon line," is an imaginary horizontal line that corresponds to the precise location of the viewer's eyes and what is seen when the viewer looks directly ahead, without tilting the head up or down. It's important to realize that the artist may move their head up or down to view an object or objects; this is called "line of vision." Even as the artist's head moves up and down, however, the eye level stays the same.

Imagine being at the ocean, where the horizon line (eye level) is easily seen. If there is an airplane traveling from the horizon toward us, we watch it get closer by raising our line of vision until it is directly above us. We have not brought the ocean edge (horizon line) up to where the plane is flying—it stays at the eye level, where it belongs. This is how the eye level and picture plane work together.

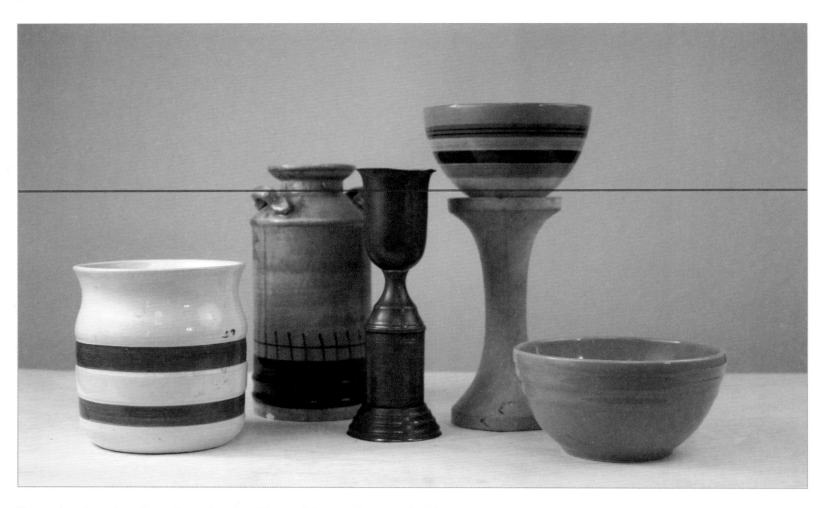

For a visual explanation of eye level we'll use this set of pots, of different shapes and sizes. Eye level is located somewhere between and within the height range of the objects, as the viewer is able to see the inside top of the objects that are below eye level, but not of those above eye level. Notice that the bases of all the objects seem to be in similar locations across the ground plane.

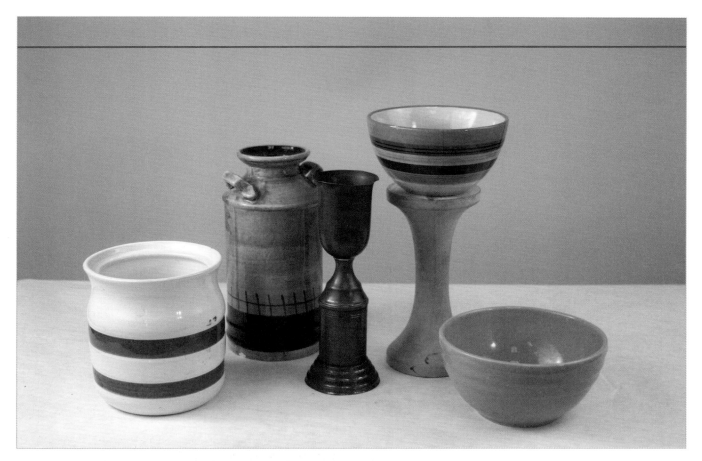

Now the viewer's eye level is above the level of the pots, and it is much easier to see inside all of them. The differences in orientation across the ground plane are more apparent, as is the space that each pot's "footprint" occupies.

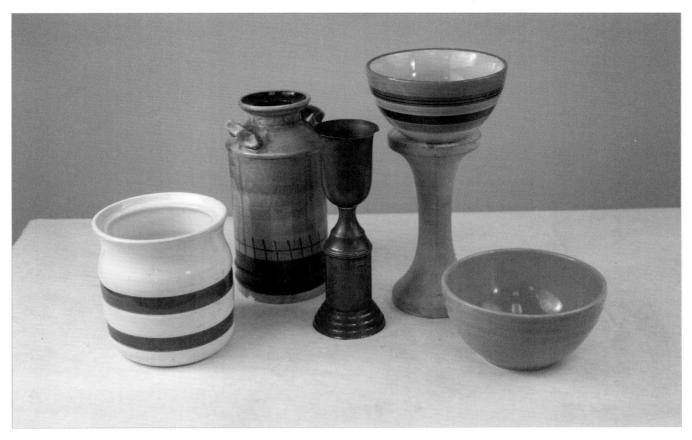

In this third picture, the eye level is higher and completely out of the image. The given space between each object is more apparent. Note that the objects nearest to the bottom of the picture plane are the closest to the viewer. This type of overhead view for a group of objects makes it easier to understand the objects' hierarchy of sizes through diminution, as well as the phenomena of overlapping forms, which also helps us understand which form is in front of another.

Other Uses for the Picture Plane

When attempting to compose a still life on the drawing surface, it is helpful to use a straight tool, such as another pencil or, in this case, a long chopstick. I give all of my students a chopstick on the first day of compositional studies and show them several helpful ways to use it. A good starting point is to use the chopstick to gauge overall implied angles that the objects present to each other within the context of the composition.

A chopstick is helpful, when used as a viewing tool against the picture plane, in understanding how objects are perceived in relation to one another. Remember to keep the chopstick parallel to the imaginary picture plane.

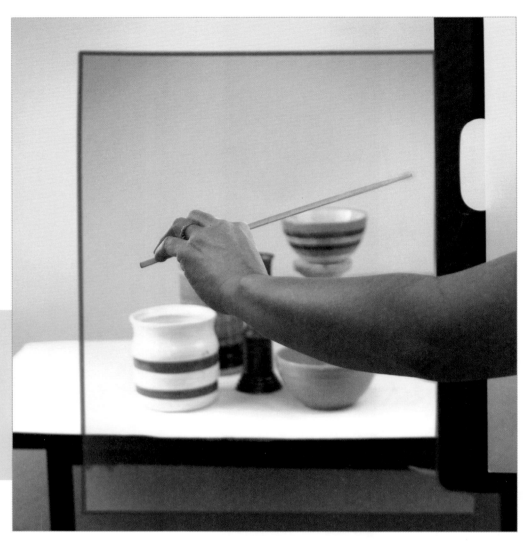

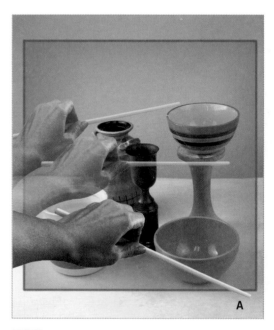

A Rotate the chopstick to observe the imaginary angles that objects have in relation to each other when viewed through the picture plane.

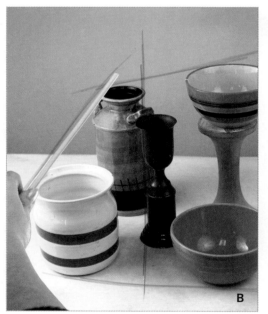

B These imaginary angular relationships can be recorded as lightly sketched lines in an overall preliminary, gestural blocked-in sketch.

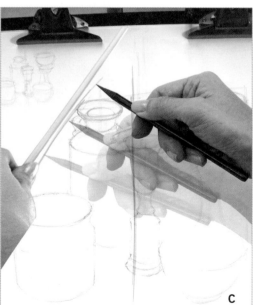

C Lightly sketch the same angles seen in the still life on the drawing surface in order to check the accuracy of the objects' placement in relation to their location on the picture plane.

As you view these angles, it's imperative to keep the chopstick parallel with the picture plane (A). The chopstick can be easily rotated around the imaginary plane, as long as this rule is followed. This way any angles of coincidence can be seen in the still life and applied to the drawing surface, as long as that surface is parallel with the picture plane (B, C).

Symmetry of Form

Symmetry refers to the similarity of form across a midline, also called an "axis." In a symmetrical object like this bottle, this means that each side of the bottle is the same, separated by a common midline (the axis), here called a *major axis*.

The axis is an invisible vertical line that runs directly through the object from top to base. Seeing the axis makes it much easier to draw any kind of symmetrical object.

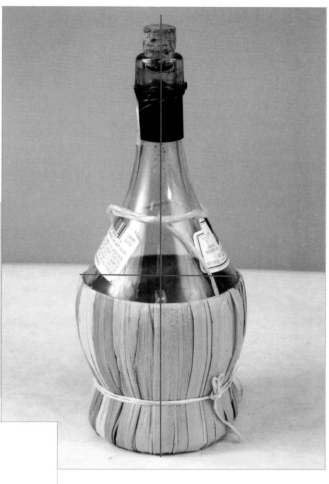

This bottle has an identical structure on both sides of its midline (blue), and is therefore a symmetrical object. The red line representing the width of the bottle is equal on both sides of the midline.

A Use a chopstick to check the accuracy of the drawing on both sides of the midline.

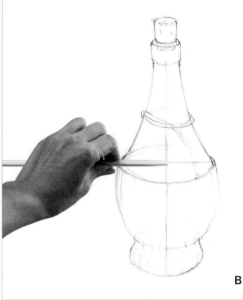

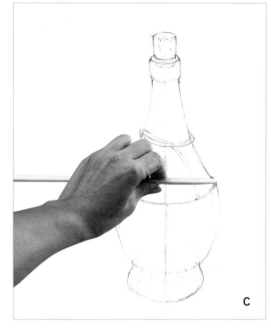

B To measure the object, place the end of the chopstick at the object's midline axis and hold the chopstick with thumb and forefinger placed at the left edge of the object. This constitutes one unit of measurement.

C Without changing your finger placement, move the chopstick laterally so that your thumb and forefinger are at the midline; the end of the chopstick is now on the object's right side. If both measurements are the same, the object is symmetrical across this dimension.

After finishing the light gesture drawing, and before moving on to a stronger, more refined drawing, I use the chopstick to gauge my accuracy and spacing on both sides of the midline axis (A). I do this at several points along the vertical length of the axis until I am satisfied that the entire object is symmetrical (B, C). If there are any instances where the symmetry is wrong, it's easy make corrections to the light drawing.

Units of Measurement

The chopstick can be very useful in finding accurate measurements of objects and proportional relationships between objects in a still life. It's important to remember that the arm must always be straight and parallel to the picture plane when measuring an object. This way any object's height or width can be used in comparison to any other height, width, or distance in the still life.

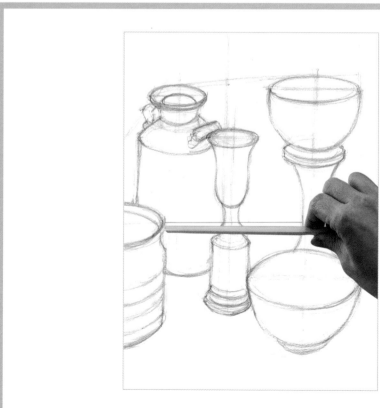

ARTIST'S TIP

Use the unit of measurement to find distances between objects, first in the measurement of the still life and then applied to the sketch. If the unit of measurement between objects is found to be inaccurate in your drawing, corrections are still easy to make at this light stage of the sketch.

In this still life, we're focusing on the pot with the blue stripes in order to find a unit of measurement to use as a baseline proportion. The thumb and forefinger are placed on the chopstick at the base of the object, while the tip of the chopstick is placed at top of the object (A, B). This is the unit of measurement that can be used to ascertain the objects' relative sizes or the relative distance from one object to another (C). This should be done after the objects are lightly blocked in during the overall gesture sketch, before any refinement or detail is added. At this stage, any necessary corrections to size and placement can still be easily made.

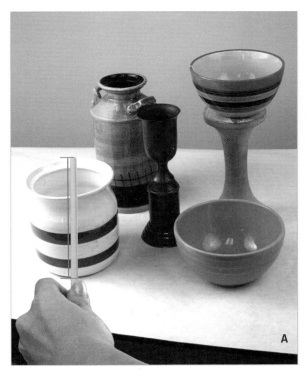

A The chopstick can be used to obtain a unit of measurement that the artist can use against other objects and spaces between objects. A good object to use for this unit of measurement is something simple and close to a squared form.

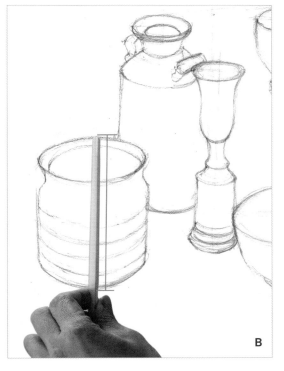

B After an initial, light blocked-in gesture sketch of the entire still life, the artist uses the chopstick to find the unit of measurement.

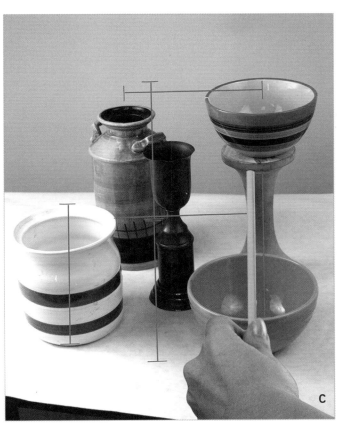

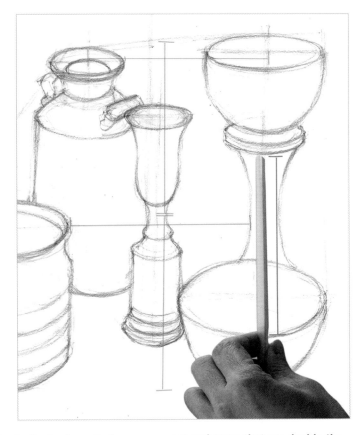

C Within this still life there are several objects that are similar to the basic unit of measurement and some that are double the unit of measurement. The same can be said for the spaces between objects.

Bringing It All Together

In this still life, the angles corresponding to the heights and locations of each object are determined with the aid of a chopstick kept parallel to the picture plane. The angles are then sketched onto the light, blocked-in gesture drawing of the still life.

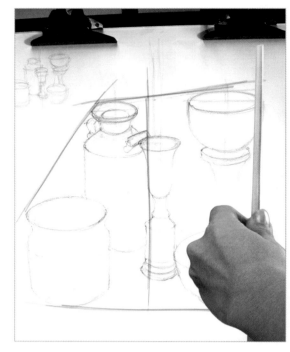
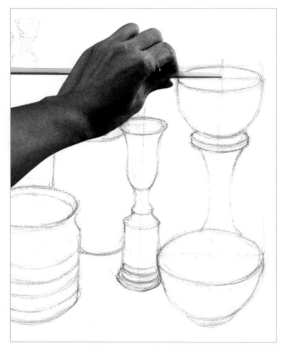

The unit of measurement for the striped pot is applied to several objects and distances for comparison, and the midline of each symmetrical object is sketched and used to verify the accuracy and integrity of each form.

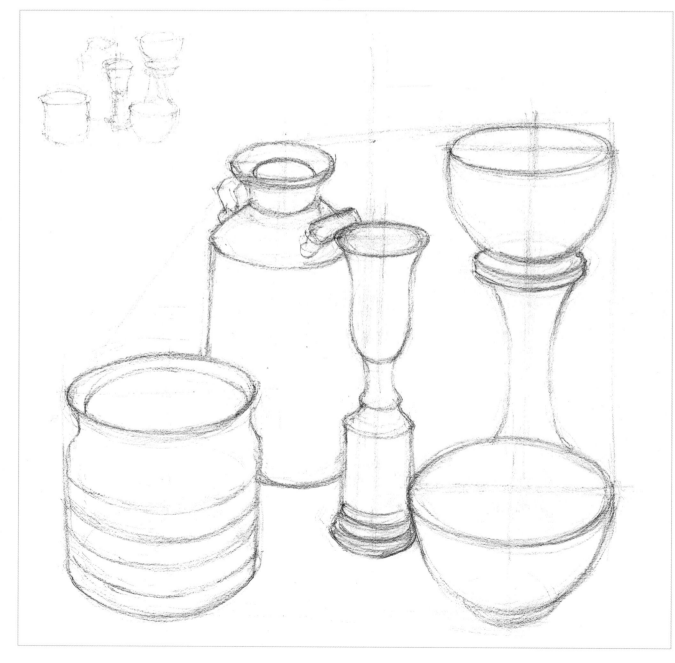

The final sketch is shown here with a small initial thumbnail sketch at top left that can be created prior to starting the large sketch. The thumbnail sketch is normally accomplished in 5 to 10 minutes and can aid in the initial placement of objects within the still life in the larger drawing.

Drawing Circles in Perspective

In this chapter, we will discuss the nature and drawing of circles in perspective, called *ellipses.* We will discuss practical techniques that are intended to aid the beginning drawing student in a fairly straightforward and accurate discussion and demonstration. Remember: Good drawing comes with a lot of practice, so once you understand what ellipses are—and how to draw them—practice whenever you are able. Nothing gives away an artist's deficiencies more quickly than a drawing with poorly constructed ellipses; even to the untrained eye, lack of accuracy in drawn ellipses can usually be spotted, although the viewer may not quite understand what is wrong with the picture or how to fix the problem.

Ellipses: Foreshortened Circles

An *ellipse* is a circle in perspective. It sounds simple, yet many artists find it challenging to accurately draw them. Once you learn some simple rules and properties of ellipses, the mysteries will be revealed, and you can successfully and easily render them.

We see ellipses in objects all around us—rims of cups, bowls, and other cylindrical objects; wheels on cars, bicycles, and roller skates, etc. Observed straight on, these forms are circular, but it is much more common to see them at angles. Therefore, it is in the artist's best interest to learn as much as possible about ellipses.

One of the most important elements that dictates how we see the shape of an ellipse is its relationship to eye level. Knowledge of eye level and its location is a key component in almost every drawing, but especially in regard to ellipses.

Wrong Ways to Draw Ellipses

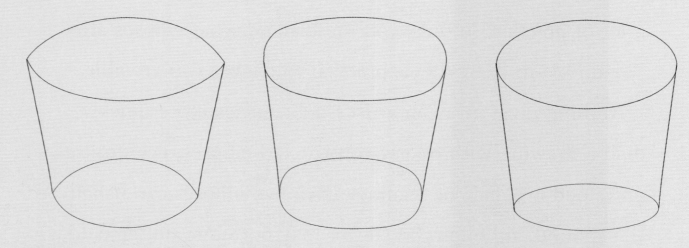

Demonstrated above are a few illustrations of the wrong ways to draw ellipses. The first example shows the classic "football" shape of an incorrectly drawn ellipse; the edges of an ellipse should always be rounded and never pointed.

In the second example, the edges of the ellipse are too rounded, with the top and bottom edges too straight across their length. Ellipses should always curve continuously and have no straight edges.

In the third example, the ratio of closed-to-open ellipses is wrong. The nearer the ellipse is to the viewer's eye level, the tighter that ellipse appears; conversely, the farther from eye level, the more rounded the ellipse appears.

Attributes of Ellipses

All circles fit into a square. When drawing an ellipse, first visualize a circle within a square and then project it into perspective to observe the foreshortening that occurs. The circle is divided into equal quadrants by a horizontal axis and vertical axis. Notice what happens when the square and circle are projected into perspective space: The horizontal axis shortens in width, and the vertical axis shortens in height.

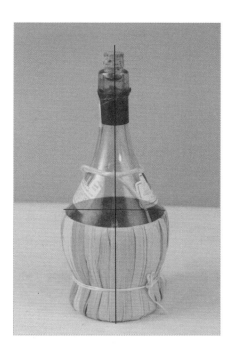 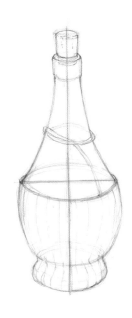

On this bottle, the horizontal axis is the major axis of the ellipse (red line). The vertical axis is the major axis of the bottle, but it is the minor axis of the ellipse (blue line). These axes are always at right angles to each other when a symmetrical object stands up straight on the ground plane. The major axis, or midline, of the bottle coincides with the ellipse's minor axis and is perpendicular to the ellipse's major axis. This is the rule when any symmetrical object's base rests on the ground plane, such as the still-life objects in the image below.

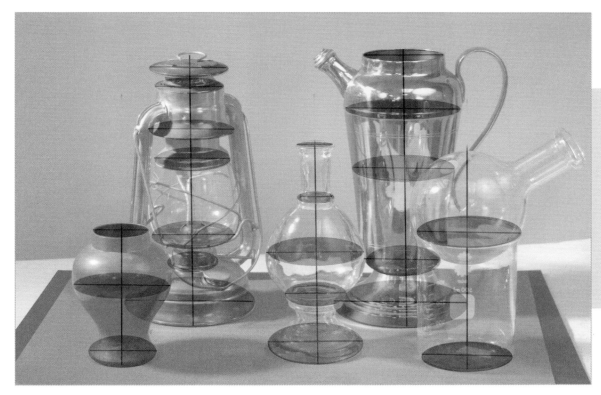

In this still life, notice the gradual change in length of the blue minor axes of the ellipses as they rise toward eye level. The relative width of the major axes (red) stays the same, however.

Size Ratio of Ellipses

Ellipses can be explained in degrees of angle to the viewer's eye level, with 90° equal to a true circle and 0° when the ellipse is viewed at eye level. As an ellipse moves toward eye level, the length of the minor (vertical) axis is reduced. As an ellipse moves away from eye level, the length of the minor axis increases. Ellipses that are parallel to each other, or in similar locations horizontally, will have very similar size ratios (see image below).

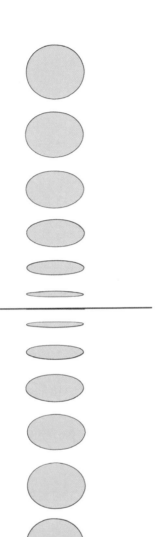

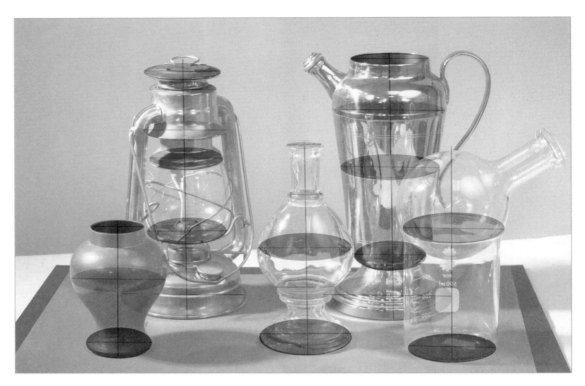

This photograph illustrates how ellipses relatively close to each other across a horizontal location are similar in their ratio of roundness. For instance, all of the ellipses at the objects' bases (magenta) have similar ratios of roundness; let's say 50°. The middle, tan-colored ellipses are all around 30° to 35°, and the very tops of the objects (purple) are about 10° to 15°, as they are the closest to eye level.

Ellipses Not Parallel to the Ground Plane

As a circular object moves away from standing vertically on the ground plane, there are similarities and differences to the ellipses that we have already discussed.

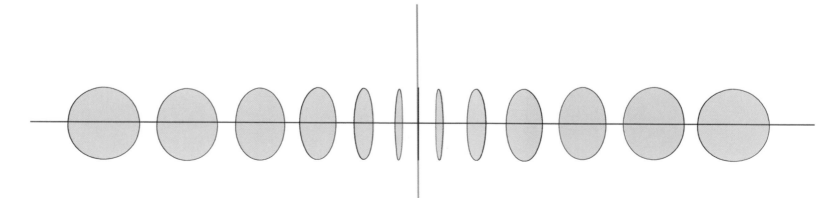

Study this photograph of four pots resting horizontally on the ground. Notice that the pot farthest from the viewer has an ellipse for its rim that is almost a straight line; as the pots rotate around the ground plane toward the viewer, the ellipse of the rim rounds out more with each successive rotation toward the viewer.

Also note that the pots tend to shift away from eye level and farther down on the picture plane. The center midline axes of the pots also present more of a perspective angle to the viewer. These midline axes are directly related to the perspective angle of the side of each pot, bisecting its symmetry.

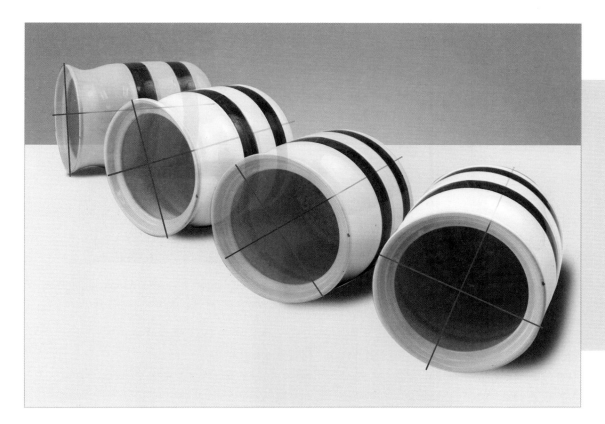

As the pots rotate toward the viewer from left to right, the ellipses become rounder, the blue midline (minor axis) becomes more of an acute angle to the picture plane, and the red major axis always stays at a right angle to the minor axis. The angle of the major axis of the pot (the minor axis of the ellipse) is dictated by the perspective construction angles of the sides of the pot.

Here is what the sketch of these pots would look like, with the major axis of the pot (also the minor axis of the ellipse) and the major axis of the ellipse sketched in lightly.

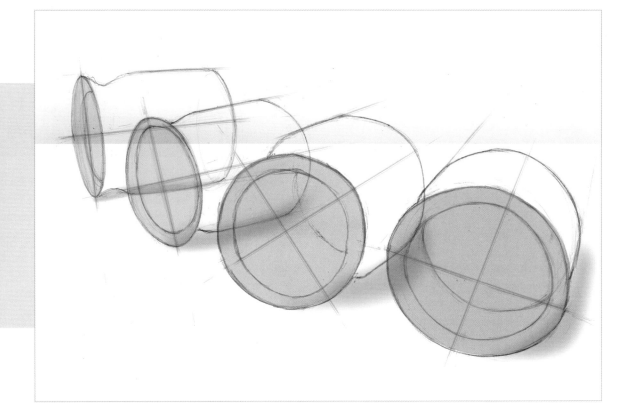

Drawing Ellipses in a Still Life

Blocking in a still-life composition is explained in Chapter 3. Refer back if you need a reminder about starting points.

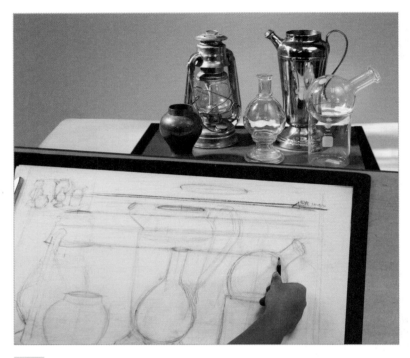

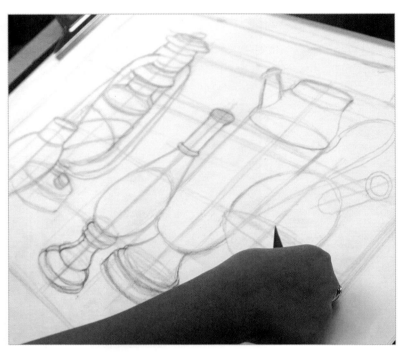

1 Make a quick thumbnail sketch in the corner to establish the objects. Then use a chopstick to see and apply visual relationships as you lightly sketch. To ensure height accuracy in each object, sketch light horizontal lines across the tops of objects and the ellipses of objects. This enables you to see which ellipses are on the same horizontal plane or on similar planes. You can then ensure that the ellipses are consistent within each plane.

2 Draw the major axis of each object freehand, remembering that the midline axes of symmetrical objects are exactly vertical.

Using a Triangle

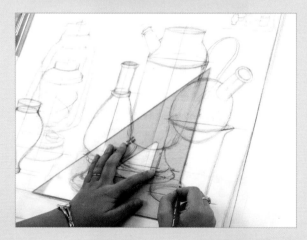

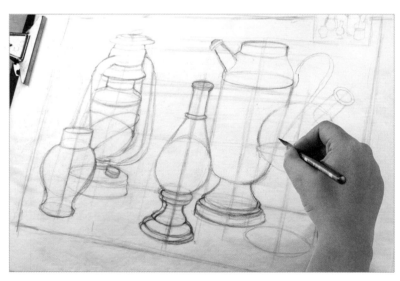

3 Check the integrity of the symmetry by using a chopstick to measure at several points along the length of each object. When all is accurate, strengthen the sketch with a contour line drawing over the light lines, using a darker graphite.

When a project calls for more refined accuracy, I recommend using a triangle to confirm the verticality of the true midline. Place the bottom of the triangle on a true horizontal line drawn below the still life. The 90° right-angle edge gives a true vertical line.

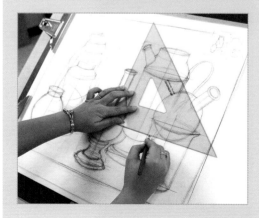

You can also use a triangle to check the horizontality of the major axis of each ellipse, which should either be a right angle or perpendicular to the object's vertical midline.

Transfer the Drawing

There are many ways to transfer a preliminary drawing to art paper for the final rendering. The method you choose depends on what type of paper is used, the value of the paper, and what type of final media will be used for rendering. Here is a technique that I teach my students for this type of project, which will be black-and-white colored pencil on dark gray toned art paper.

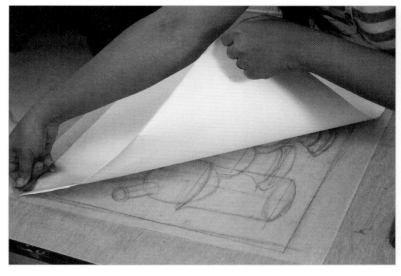

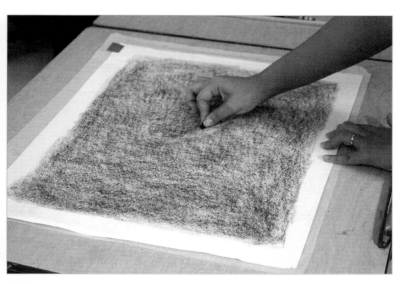

1 First tape a separate piece of white or tracing paper to the back of the drawing. This white sheet will enable you to see the line drawing when you apply dark pastel on the back of the tracing paper sketch after it is turned right-side up.

2 I like to use a dark coat of pastel, typically a combination of dark brown and black. Dark Conté crayons work equally well, as they have a waxy quality that makes for a nice, easy transfer. Liberally apply pastel to the back of the drawing and rub it in with your finger or a paper towel.

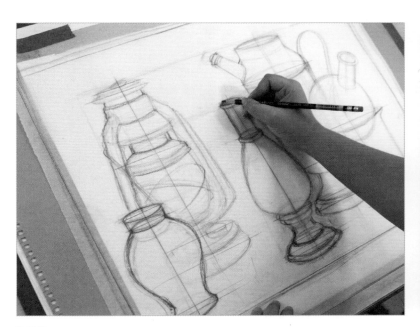

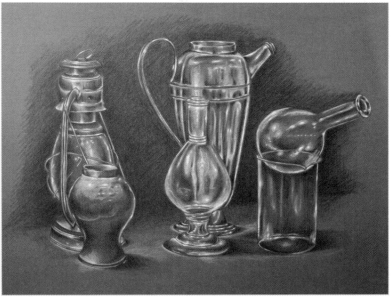

3 Turn the paper right-side up, with the sketch facing you, and tape it securely in place to the toned art paper. Then trace over your sketch. I use a different colored pencil for re-drawing/transferring so that I can clearly see what I have already transferred.

4 With the initial sketch transferred to the toned drawing paper, you can develop the drawing to a full rendering. (Final tonal drawing by student Polly Hung.)

YOUR HOMEWORK

For your homework assignment, set up a simple still life (two or three objects), using glass and reflective-surface subjects. Create a line drawing using all the techniques for measuring and symmetry you've learned in this chapter. You'll find it helpful to use objects of differing sizes and shapes.

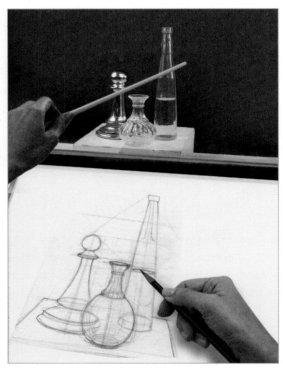

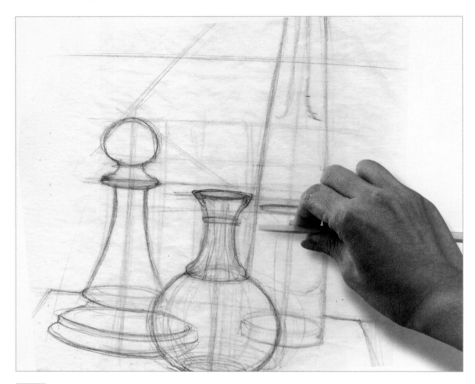

1 Start by blocking in the overall sketch envelope around the still life, and create a gesture sketch, without a lot of refinement.

2 Use a pencil or chopstick to check for accurate symmetry on each object. Draw the vertical midline (axis) for each object freehand.

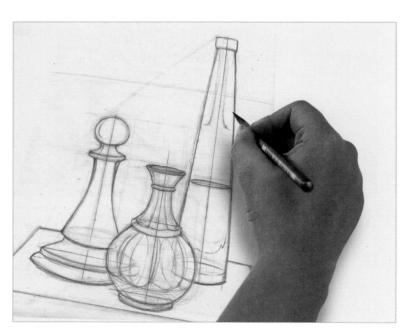

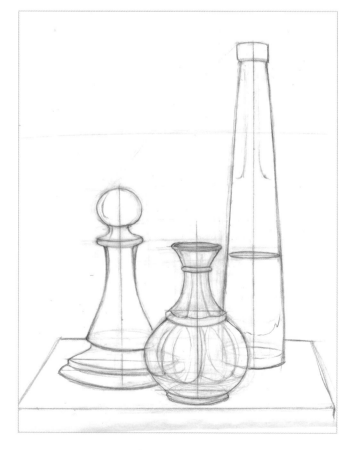

3 Refine the midlines with a ruler or a triangle (I use a red pencil for this), and further refine the contours and shape of each object.

4 Here is the finished contour line still life, with an indication of the ground plane.

Perspective & the Picture Plane

In the previous chapter, we discussed how to draw circles in perspective. In this chapter, we will focus on accurately drawing non-circular, hard-edged objects—boxes—in perspective. We will also discuss further uses of the picture plane, new information on applying accurate object dimensions and sizes in a complex still-life arrangement, and the best way to simplify a complex arrangement at the onset in order to more easily and successfully block in the subject matter.

Part I: Perspective

Perspective is essentially your viewpoint. When someone asks you how you "feel" about a subject, the person wants to know your point of view, or your perspective. In drawing, we relate perspective to how the subject is viewed by the artist. For example, when you stand at an easel and draw a subject, you see the subject from a different viewpoint, or perspective, than you would if you were sitting in a chair and drawing the same subject.

Perspective Terminology

Perspective Drawing When we draw from observation, we are depicting three-dimensional objects in front of us onto a flat surface—the drawing paper. We are attempting to give these objects dimension, depth, and an impression of reality.

Line of Vision Also called the "line of sight," line of vision is the direction in which the viewer is looking.

Picture Plane As discussed previously, the picture plane is an imagined, transparent sheet of glass between the viewer and the subject. The picture plane is perpendicular to the ground plane.

Vanishing Point The vanishing point is the point where retreating parallel construction lines converge. Vanishing points are usually on eye level. (Exceptions include three-point perspective and inclined planes, which will be discussed in a later chapter.)

Horizon Line Also called "eye level," the horizon line is an imaginary line consistent with our eye level. It stretches horizontally across our view and is the location of all of the vanishing points in a drawing.

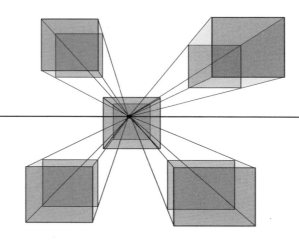

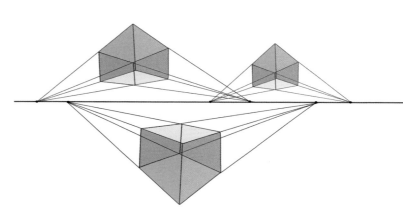

One-Point Perspective
In relation to box-like constructions like the examples here, or in the case of interior or exterior architecture, one-point perspective is indicated by a front plane and back plane, each parallel to the picture plane, with two side planes that converge toward a common vanishing point within the picture plane. The vanishing point is always on eye level.

Two-Point Perspective
In situations similar to the box-like constructions shown, only the vertical edges of the boxes are parallel to the picture plane in two-point perspective. The parallel sets of sides converge diagonally toward common vanishing points, one on the right side of the picture plane and one on the left. Both of these vanishing points are always on eye level.

Ground Plane
The ground plane is the plane on which the drawing subject sits. For objects resting on a table, the ground plane is the tabletop. In architectural structures, the ground plane is literally the ground. Eye level is always parallel to the ground plane; however, eye level and the ground plane are rarely the same.

Eye Level

Now that you have some familiarity with perspective terminology, let's put these terms to use in tangible situations. Drawing boxes is a very good way to understand the principles of still life, or "tabletop," perspective.

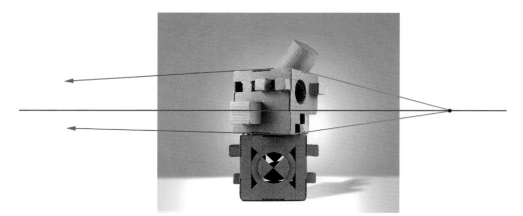

In one-point perspective, the front and back of the boxes are parallel to the picture plane, and the vanishing point for the perpendicular sides is within the picture plane.

Imagining that the picture plane is located vertically between the boxes and ourselves, we'll start by viewing a two-point box on top of a one-point box, with eye level within the picture plane. For the two-point box on top, the convergence of its edges is toward eye level, and the subsequent vanishing points are on eye level, one on the left and one on the right. Because the one-point box on the bottom shows only its front face, we know that it is parallel to the picture plane and that its vanishing point is directly behind it, also on eye level.

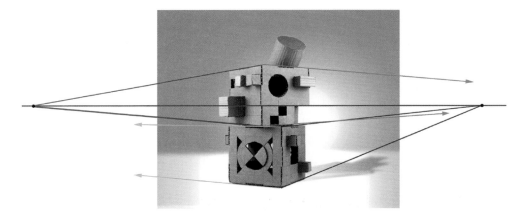

From this angle, both boxes are now considered two-point boxes. The parallel faces of each box converge to common vanishing points on eye level.

As we rotate the box construction slightly, we can now see that both boxes are in a two-point perspective situation, but each box has it's own left and right vanishing points, still on the horizon line.

The boxes are still two-point boxes, but now the eye level is above the level of the boxes. The viewer can see the tops of the boxes easily, and the angles of convergence are more acute.

In this third view, the eye level has risen above the picture plane, and the line of vision is looking down onto the tops of the boxes. These new angles of edges, especially on the bottom of the lower box, are particularly acute, with vanishing points now much closer to both boxes than they were at previous locations on eye level.

Drawing the Two-Point Perspective Setup

As you can see from several different viewing angles, the vanishing points for one side or the other can be fairly distant from the box, many times off the edge of the paper. If the front face of a box is slightly turned from a one-point perspective, the diagonals of the face converge to a vanishing point far from the box. In order to draw the boxes accurately, we need a way to illustrate the angles of the boxes' edges without the vanishing points, which are sometimes (or usually) outside of the picture plane. The way to achieve accuracy is with an angle tool—in this case, a chopstick—which can help us see any angle that the boxes present, as long as we keep it parallel to the picture plane.

1 Check the angles with a chopstick, and then mark the top and bottom of each box to establish proportions and composition. Sketch lightly and loosely.

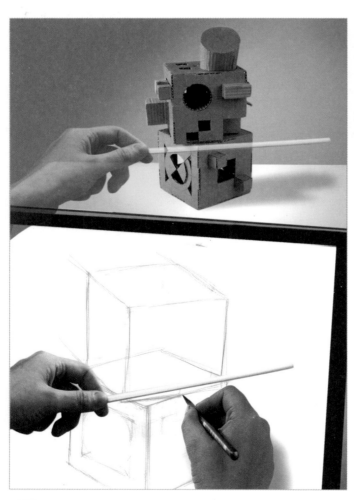

2 Once the boxes are lightly sketched, start to establish the accuracy of all the angles, in this case starting with the bottom box and moving on to the top.

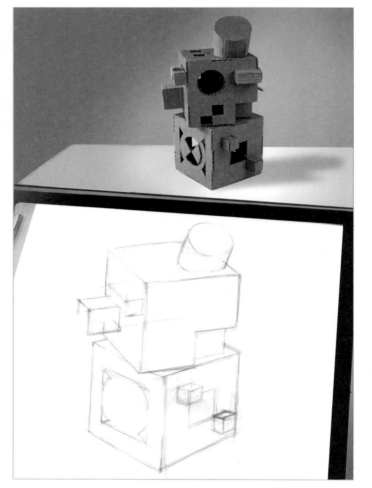

3 When you are certain of the accuracy of the converging lines, strengthen and refine your drawing. All of this is accomplished without rulers! A ruler may give you a straight line, but it does not necessarily give you an accurate line. Your eye and a good freehand sketch can do a better job.

Part II: The Picture Plane & the XY Grid

Now we will use the picture plane in front of a more complex set of objects that make up a large still life. We will again use a chopstick as a tool for angles and relative sizes, but also for accurate locations. A chopstick is helpful in finding angles on the picture plane when held diagonally, but it can also be used horizontally and vertically to help us line up the subject matter in a simple, straightforward way.

By using the chopstick horizontally and vertically at various points of intersection in the still life, we can superimpose an imaginary grid over our drawing of the still life. The horizontal lines are called "X-axis" lines, and the vertical lines are called "Y-axis" lines. The imaginary grid is called the "XY grid."

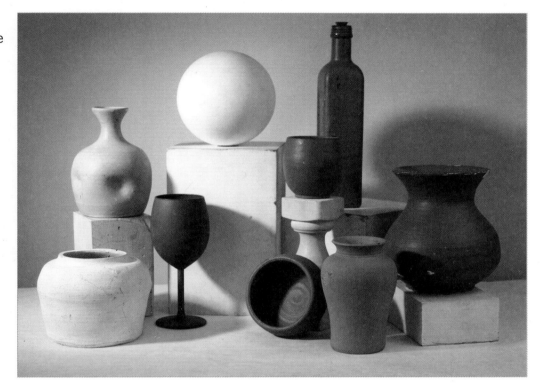

We will use this complex still life setup to demonstrate the use of the XY-grid construction method.

Using a Viewfinder

You can purchase a viewfinder at an art supply store. Viewfinders help the artist pre-visualize what their composition will look like on the page. The format (size) of the paper can be adjusted with a movable interior slider.

I find that a simple plastic slide frame does a similar job of framing the composition. The proportion of the slide opening is similar to most standard art paper sizes. Try blocking in the overall composition with quick marks that reflect the top, bottom, and sides of the composition while looking through the slide.

The Drawing Process

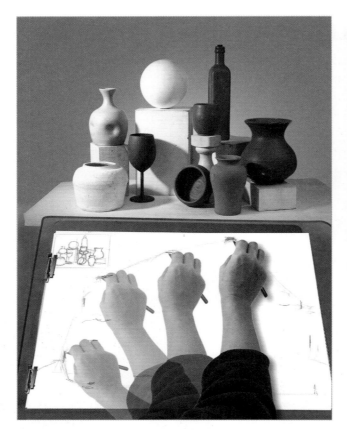
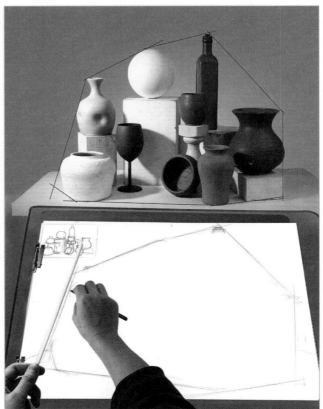

1 After making a thumbnail sketch, start by marking very generalized locations of the tallest, lowest, and widest form edges of the still life. Don't worry about detail; just concentrate on the top, bottom, and general location of each object. Then use the chopstick to create an "envelope" around the entire still life.

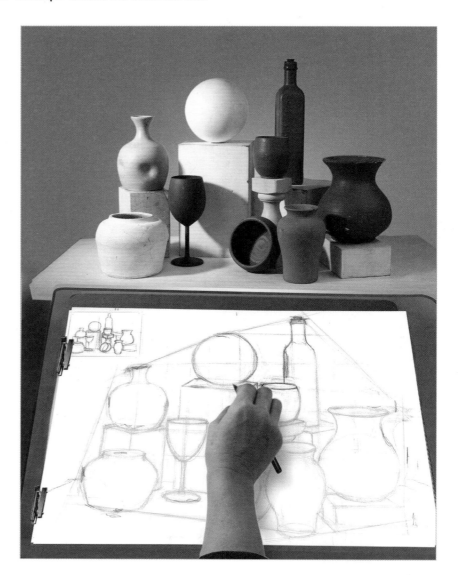

2 Next is the initial block-in stage. This stage is not about detail or refinement, but only general scale, proportion, and placement. Make use of the chopstick as a proportional measuring tool by selecting one object in the still life to use as the base unit of measurement for all the other forms.

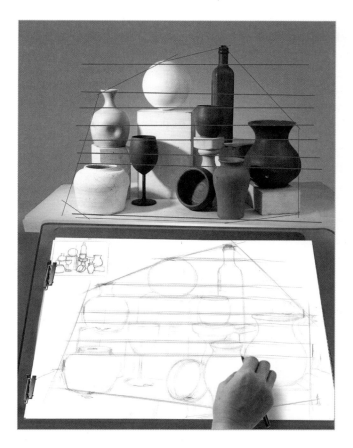

3 Once most or all of the objects have been blocked in lightly (light forms are key; they are easier to refine and adjust), the XY grid can be initiated. As you check the first horizontal X-axis on the still life, notice which other objects' heights fall across this line, and apply that information to your drawing with a light horizontal line. If you need to make an adjustment to a form or its location, make a mark for that change. If you have sketched accurately, you won't need to make many adjustments; move down to the next point of intersection on the still life and create another X-axis on the grid; sketch this on your drawing as another light horizontal line.

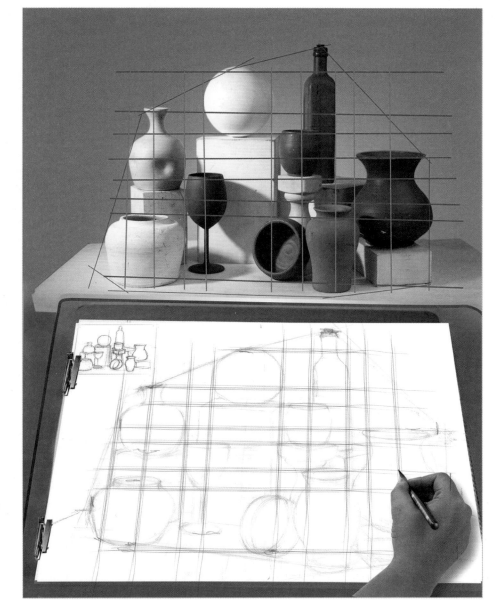

4 As you move down the still life, you should be able to adjust most or all of the height locations of the objects. Then it's time to check the width and horizontal locations of objects with the Y-axis lines, making sure that all objects are properly aligned with one another. Transfer the imaginary Y-axis lines on the still life as light vertical lines on your drawing, so it resembles a horizontal and vertical grid.

YOUR HOMEWORK

Based on the first demonstration in this chapter on page 42, create a still life of stacked boxes (at least three), with your eye level somewhere between the top of the highest box and the base of the lowest box; turn the boxes at different angles to one another.

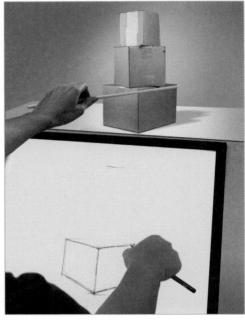

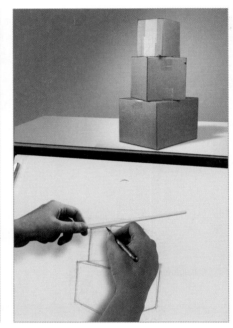

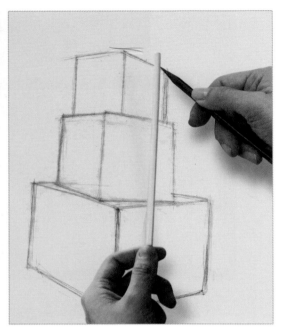

1 Mark the top and bottom of the composition based on the highest point of the top box and the lowest corner of the bottom box, respectively. These are "guesstimates" only and may be adjusted during the course of the drawing. Start with the bottom box sketch, checking angles of edges with your chopstick or pencil.

2 Use a pencil or chopstick to gauge angles on the still life, and then apply the angles to the second box.

3 Check for vertical edges on all corner of all of the boxes; refine if needed.

4 Refine your drawing with weighted contour line, and indicate a ground plane.

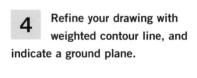

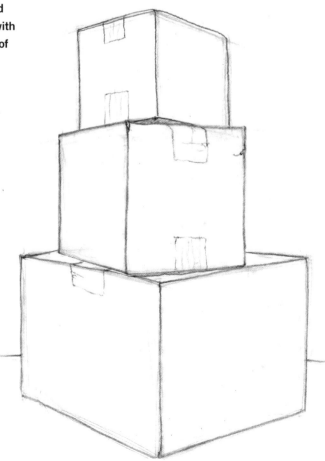

Composition

A composition is a visual organization of forms into a unified, balanced, harmonious arrangement. In the case of drawing, this is accomplished on paper. The elements that we use and the principles that we employ in their arrangement make up our composition.

Many artists and art instructors rely on intuitive skills to attain successful compositions, and this is fine. However, it is also a good idea to know and review some of the tenets of what really constitutes a successful composition.

Ask yourself: Is there balance in the forms or subject matter within the composition? Do your eyes move freely around the composition? Are there focal points to pull your interest to the composition or to individual objects? Is there a variety of shapes and forms for interest, or is there a chaotic mix of disparate objects arrayed with no connection to one another? These are just a few of the questions that will be discussed in this chapter to help you employ successful composition design.

Elements of Composition

The elements of composition are point, shape, mass, volume, texture, value, and color. Let's talk about them one by one.

Point

A point is a single mark on a page without depth, height, or length. A group of points in a row or an arc can create a line—or at least imply a line. Points used closely together can suggest a three-dimensional object.

Line

Geometry defines a line as an infinite number of points. A line is the earliest tool that most children use intuitively to visualize and represent the world around them. A line represents the building-block foundation of most drawings. Lines can be bold, weak, varied, geometric, organic, energetic, or calm. We discussed gesture and contour line extensively in Chapter 1 (see pages 8–10).

Line drawings are an integral foundation for all further exploration of drawing; they are the gateway to visual expression in other forms of art as well.

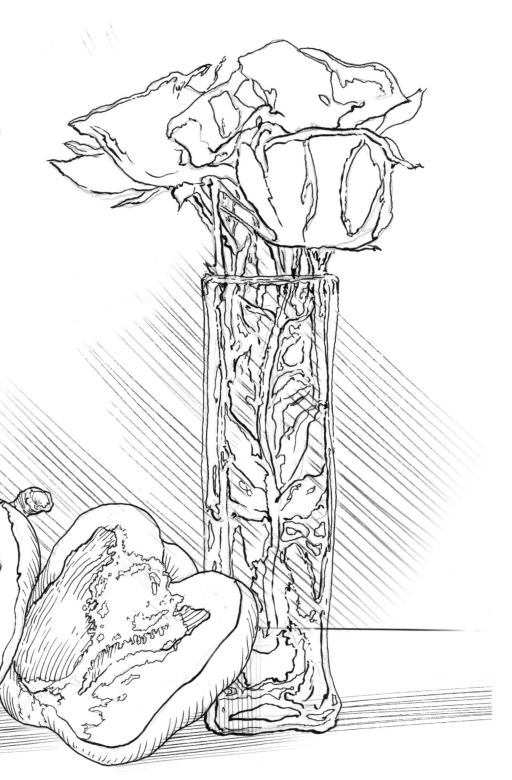

Shape

A shape can also be called a "form." A shape is usually considered to be an area or object that is either: (a) completely enclosed by lines or (b) perceived as a separate entity through isolation of shape (through contrast of value or color). In the example of positive and negative space, the recognizable shape is the positive shape while the area around the form is the negative shape. This is also called the "figure and ground" relationship. Negative shapes can be just as interesting as positive shapes.

Also called the "figure/ground relationship," the recognizable shape of the subject becomes the positive shape or form, and the space around it becomes the negative shape (A). Shape can be bold and dramatic, with the negative area around the shape becoming just as interesting as the positive shape (B).

Volume and Mass

While shape usually defines a flat form or area, "volume" or "mass" is the terminology used to describe a form with three-dimensional qualities. Architecture and sculpture are associated more with mass and volume than drawing or painting. However, mass and volume can be inferred on a flat, two-dimensional surface through strong contrasts in value—light and dark—within a drawn object.

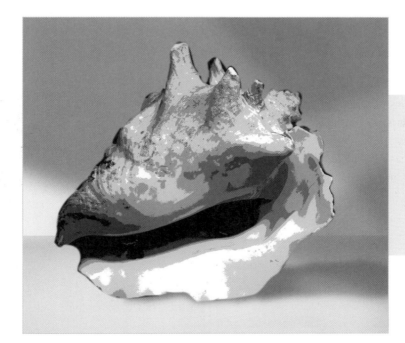

The close cropping of the format, along with the high contrast across the form, gives this shell solidity and weight, or mass.

Texture

Texture refers to the tactile quality, actual or rendered, of an object. In a drawing, texture isn't so much the surface on which we work, but rather the way the artist manipulates the drawing materials to evoke a textural feeling. We work to create a visual depiction of a texture. However, there are certain textural qualities inherent in various paper surfaces that can help facilitate a smooth surface, a mottled surface, a rough surface, or even a wet surface. This is part of the magic that an artist can bring to a drawing for the viewer.

Texture takes on many examples here, ranging from the rough quality of the fabric and the pebbly surface of orange skin to the slick, metallic quality of the vase and the wetness of the sliced orange.

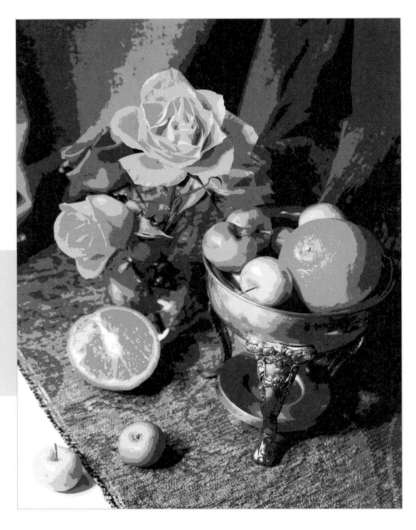

Value

Value is the range of light from white to black, or very light to very dark. Values in a drawing help us determine the direction of the light source and the shapes and structure within a form. Value also helps explain and portray depth in a drawing; dark values appear to advance toward the viewer, while lighter values tend to recede into the background. Additionally, high-value contrast within a form can bring the object closer to the viewer, while low-value contrast makes the object move away from the viewer. This phenomenon is also known as "atmospheric perspective."

This is an example of high-contrast value, with a range of values from very dark to very light.

Color

An entire book could be written just about color, and many have been! There are a few important basics to know about color. Color is all about light and the way it affects our perception of an object. In two-dimensional artwork, we attempt to portray the effects of light on a form or object through the color mixing of pigments and dyes.

Color has three important characteristics: *hue, saturation,* and *value.* Hue is the actual name or family of color, such as "blue," "red," or "green." Saturation, or "intensity," refers to the brightness or dullness of a color. A pure blue pigment has a much higher intensity, sometimes called "chroma," than a blue that is mixed with its complement on the color wheel (orange). Value refers to the darkness or lightness of the color. Color is discussed more comprehensively in Chapter 10.

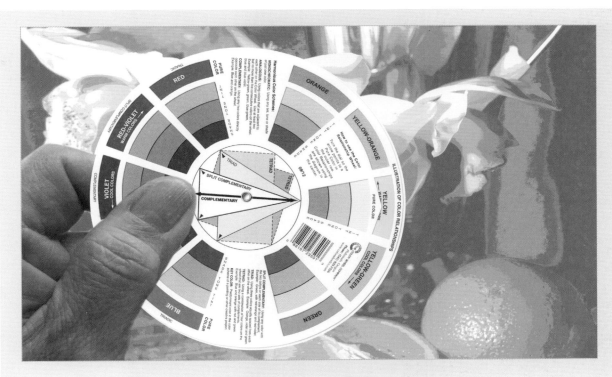

Color Wheel

A color wheel is a helpful tool that not only describes the color, but also gives information on harmonious color combination and mixtures.

Format

The outer edges of a drawing (sometimes the edges of the paper itself), or format, guides your composition. It is often either a square or rectangle. If it is a vertical rectangle, it is called a "portrait" format. If it is horizontal, it is called a "landscape" format.

Principles of Composition

A pleasing composition appears balanced and harmonious, with the various elements working together to create an eye-catching scene. There are a variety of ways to achieve a good composition. Over the next couple of pages we'll discuss several principles of composition and how to use them to achieve a well-balanced drawing.

Unity

Unity is the overarching dynamic that integrates and connects visual imagery into a cohesive and successful composition. The path to unity starts with understanding how different principles of design can help the artist attain unity in a composition. In good composition there should be a feeling of a plan, not a random arrangement of forms.

There is a structured feeling in this photograph due to the combination of flowers, which unify the composition with recognition; however, the variety of shapes, heights, and values add interest to the composition.

ARTIST'S TIP

You can also achieve unity with repetition. In this image, note how the repetition of shells promotes unity with recognition, yet the different types and sizes add just enough variety to keep the composition from being static.

Variety

A composition that includes variety is typically more interesting than a rigid repetition of similar shapes. Different sizes, shapes, and values add variety to a composition.

Emphasis

Emphasis in a composition will help lead the viewer's eye to a *focal point*, or area of interest. This can be achieved through contrasting values, particularly high contrast (A). You can also achieve emphasis in a composition by using contrasting colors or a combination of hard and soft edges. The focal point of a composition is the best area to use a combination of hard edges, high value or color contrast, and lines or edges that direct toward the focal point. These diagonals or curves are called "directional forces" (B). Emphasis may also be achieved by isolating the focal point from the rest of the composition (C).

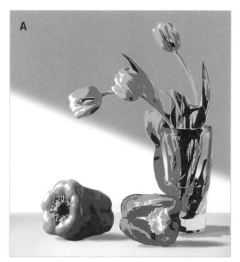 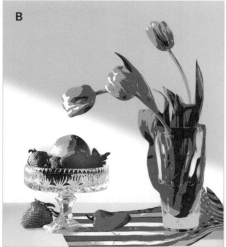 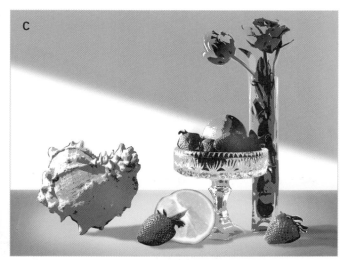

Harmony

Harmony is achieved through the orderly arrangement of elements that creates a unified composition. There are various ways to achieve harmony, including the repetition of shapes, values, or colors, which creates patterns for the eye to follow. The term "harmony" is more closely associated with music, but harmony and rhythm in a drawing composition bear similar characteristics: an orderly repetition of elements in a flowing and pleasing pattern.

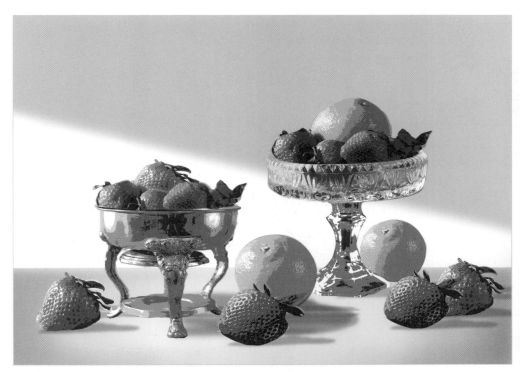 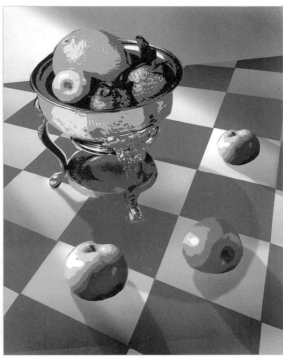

Harmony in a composition can be achieved with the repetition of similar shapes throughout, such as the strawberries in this image, to tie different elements together into a unified design.

The pattern on the ground plane in this image is accentuated by the placement and repetition of similar shapes around the vase. Pattern can also add to the feeling of harmony in a composition.

Balance

Balance in a composition generates a feeling of equilibrium in the emphasis or weight of objects in relation to one another. Symmetrical compositions are the same on both sides, practically mirror images. Symmetrical balance is also called "formal balance." In asymmetrical balance, the two sides appear to have the same visual weight, though the arrangement may consist of objects of unequal sizes or weights. Asymmetrical balance is also called "informal balance."

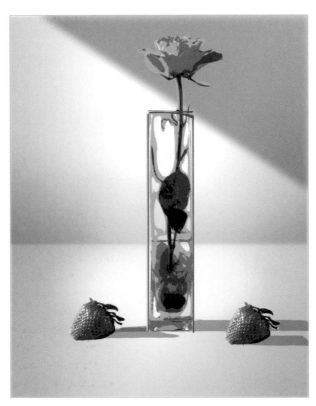

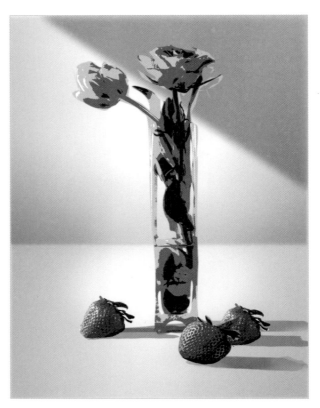

SYMMETRY Symmetry is the same arrangement on both sides of a strong central form. This formal balance in a composition can sometimes be visually unexciting and seem static.

NEAR SYMMETRY This is a more pleasing arrangement of forms that is still very symmetrically balanced.

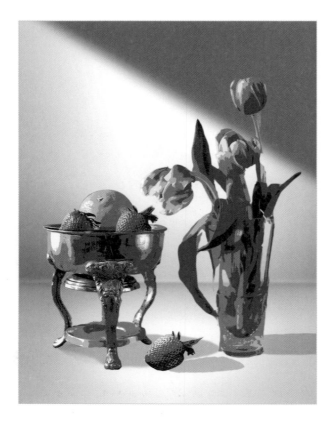

ASYMMETRY In general, asymmetry is achieved through equilibrium of objects that, even though they may be different in scale and proportion, are equal in weight.

Proportion and Scale

In design, proportion refers to the relative size of objects to each other. Scale is another word for size. Scale and proportion are closely related to emphasis and focal point.

The Golden Ratio

Also called the "golden rectangle," this mathematical construction was developed by the ancient Greeks to represent the perfect ratios and proportions on which to base their architecture and design. These proportions have influenced art and design throughout the centuries ever since. The golden ratio is: width is to length as length is to length plus width.

A variation on this becomes the "true golden mean." By adding a square to the long rectangle, another smaller—but proportional—rectangle is created. This process can be continued infinitely, if desired, and the resulting smaller perfect proportion will always be the same.

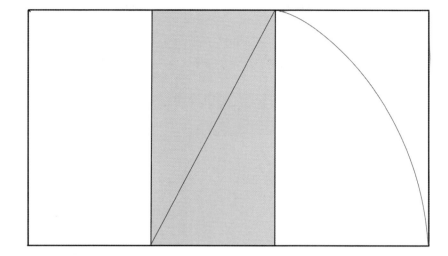

The golden rectangle can be created by rotating the diagonal of the half square (blue).

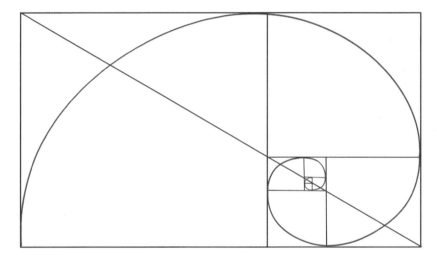

Many artists, designers, and architects believe that the convergence of increasingly smaller squares in this variation of the golden ratio creates the most desirable area of focus in a composition.

Rule of Thirds

A simplified and equally effective mathematical formula for locating focal points is called the "rule of thirds." This rule divides the format into nine equal divisions with two equally spaced horizontal lines and two equally spaced vertical lines. The points at the convergence of these lines, as well as the lines themselves, are effective locations for guiding the eye successfully around the composition. Aligning a subject along these lines creates more interest, balance, and energy than simply centering the subject or randomly placing it in the composition.

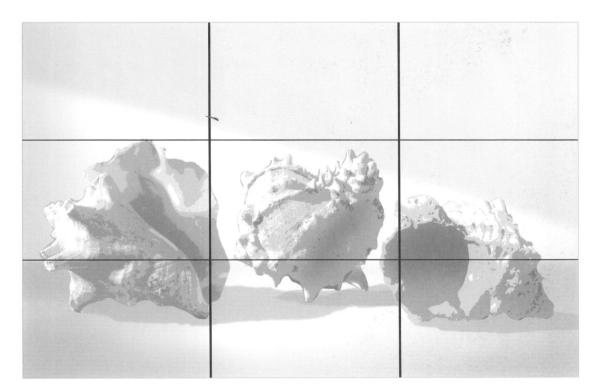

Many artists and photographers use the rule of thirds, an effective and simplified formula for successful focal-point placement. The rule of thirds divides an image or subject into nine proportional segments. The points at which the lines converge are effective focal points.

YOUR HOMEWORK

Your homework for this chapter is to create a flower arrangement—using either real flowers or synthetic—and place them in a vase or hang them from a string or wire on the wall in front of your drawing board. Start with an overall gesture drawing quickly executed with light line (preferably using an H or HB pencil). Block in the entire still life in 15–20 minutes as you continually move around the gesture drawing, defining the forms with a line that is still lightly drawn, but a bit more refined.

Finish the drawing with a weighted contour line using a darker graphite pencil, such as a B or 2B, or both.

Graphite Tonal Application

In this chapter, we will discuss the qualities and perception of *value*—gradations of illumination from very light to very dark— and how to portray the value range accurately in graphite. Graphite is a great medium with which to learn the process of value application, as graphite lead is manufactured in a wide tonal range, from very light (hard leads) to very dark (soft leads). The process of applying graphite gradations, combined with extra time in making sensitively applied pencil strokes, can be effective and logical and, ultimately, give the viewer an accurate account of the subject's value structure.

Value & Light Logic

We perceive the visible world around us because of light on form, or *illumination*. When the artist adds value, or tone, to an object in a line drawing, its volume, texture, surface, direction, and depth become more apparent, and the object takes on a reality that is immediately apparent to the viewer.

Value Scale

As explained in Chapter 6, value represents the visual range of light to dark, with successive gradients of gray between. Creating a value scale is a great exercise to help the beginning artist understand value perception. A value scale typically includes less than 10 gradients, from white to black.

In this still life drawing, I have identified a nine-value range, with a true 50 percent gray at the center of the scale and four light values and four dark values on either side of it. These basic forms are a helpful example of how light affects the surfaces and forms without influences of texture, surface irregularity, or surface complexity. There is a certain predictability to this type of lighting situation, which we call *light logic*.

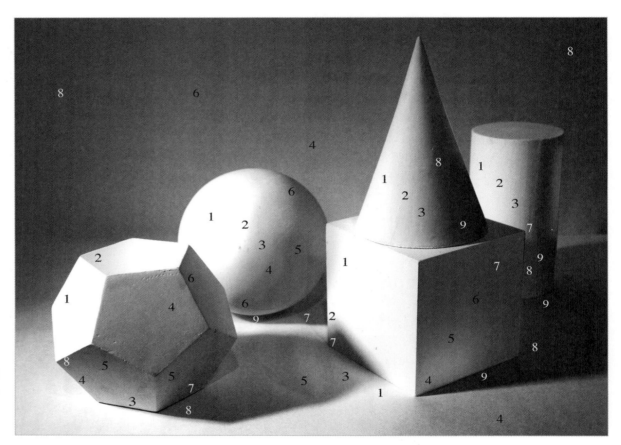

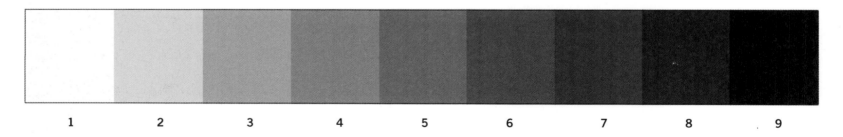

| 1 | 2 | 3 | 4 | 5 | 6 | 7 | 8 | 9 |

These simple geometric shapes (with a strong single illumination source) present a good example of the range of values inherent in a still life. Each form presents generalized rules of light logic, as well as specific light characterizations. Notice how the numbers in different areas correspond to the numerical value range.

Light Logic

In the drawings here, the effect of the light on the forms is called *chiaroscuro*—an Italian word that essentially means "light and shade." This type of lighting situation uses a full tonal range and gradual transitions from very light to very dark. It produces dramatic value changes and promotes strong three-dimensionality. Just as we tend to simplify a value scale into gradual but understandable units, there is a system of terminology that describes the effects of light on a form (see below).

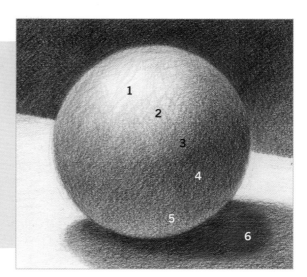

1. Highlight

2. Light

3. Shadow

4. Core Shadow

5. Reflected Light

6. Cast Shadow

Light Direction/Light Source It is vital to understand where the light that shines on an object is coming from, as well as the importance of keeping that light source separate and singular. The artist should understand how the light source direction, proximity, height, and intensity affect the appearance of the objects.

Highlight is the area of a form that receives the most direct effect of the singular light source.

Light describes the overall area of a form that receives generalized directional lighting from a single light source. On flat planes, the light is uniform; on curved surfaces, the light diffuses as the rounded form curves away from the light source. These subtle differences are evident in value transitions on spheres, cones, and cylinders.

Shadow describes the area of a form that does not receive any light. On rounded forms, the transitional change that separates light from shadow is very soft and gradual. On a hard-edged surface, such as a square, the definition is sharp and clear.

Core Shadow is the darkest area of the shadow; it receives no effects of light from the transition zone between light and shadow or from reflected light on the side of the form that faces away from the light source.

Reflected Light bounces off another lit form or surface into the form's shadow area. On a curved surface, reflected light usually appears on the shadowed edge of the form—the side opposite the form's lit side.

Cast Shadow is the shadow an object casts onto the surrounding surface, ground plane, or other object. Cast shadow is diffused, and it softens as it moves away from the form.

Student example of this value exercise, with simple forms in strong, single-light illumination.
Time: 3-4 hours
Medium: Graphite

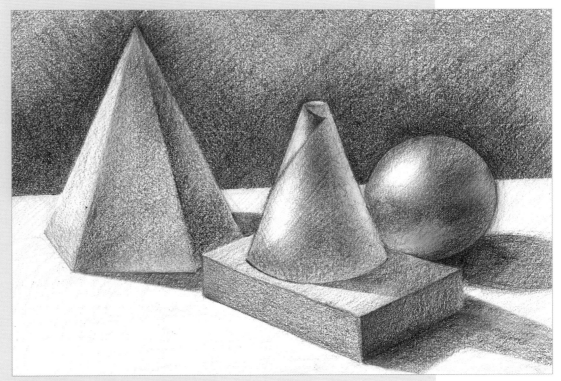

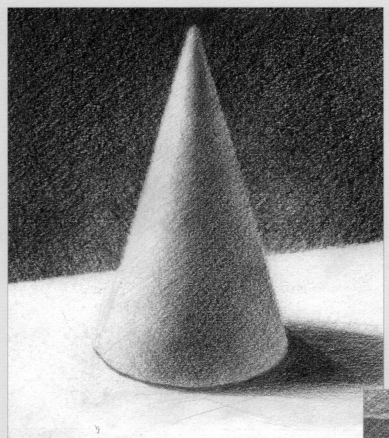

Cones and cylinders share similarities to the light logic inherent in spheres, but the core shadows and reflected light correspond to the length of the object, with subtle variations across its entire length. Consider how the reflected light on the shadowed side of a cone subtly transcends from light to dark as the dark background changes to the lighted surface of the ground plane.

Hard-edge forms like these boxes present high-contrast lights and darks, unlike the soft light-to-dark transitions of spherical and conical forms. Notice how the value on a plane in shadow can vary depending on the amount of light that is reflected onto it. Note also how the edge of a plane in shadow that abuts the lit edge of another plane can look much darker.

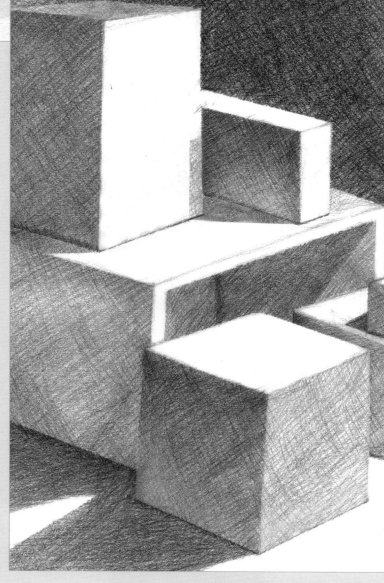

Graphite Value Scale

Graphite is a good medium to use to simulate subtle value changes from very light to very dark. Graphite pencil grades range from 9H (lightest) to 9B (darkest), but I recommend creating a value scale with no more than six to eight pencils.

The value scale shown below was completed with six pencils. To create tone, I used hatching—simply drawing lines across the paper. For darker tones, I crosshatched, drawing lines in the opposite direction of the hatched lines. The more you crosshatch in multiple directions, the darker the surface will appear.

H	HB	B	2B	4B	6B

ARTIST'S TIP

I created the value scale above on paper with a vellum surface, which has slightly more tooth, or texture, than smooth drawing paper. I chiseled the pencil tips to a 45° angle with a sandpaper pad. The resulting softer pencil tip creates wider and lighter pencil marks. For a darker surface or a more pronounced mark, keep the pencil point long and sharp.

Detail of a drawing by student Yea Jin Shin. Note the application of crosshatching in order to achieve value variations on the shadow surfaces of the flower petals.

Tonal Application Exercises

Shell

Follow along in your sketchbook with this shell demonstration drawing. In this project I layer, or *glaze*, one pencil grade over another, from lightest to darkest, with hatching and crosshatching. I never purposely smear or blend the graphite layers with a stump, cloth, or finger, as blending tends to give the drawing a muddy or dirty look. While this method can be more time consuming, the process is more logical and produces tangible, visible results.

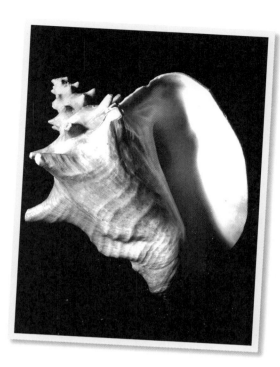

1 After making an overall gesture drawing of the shell, I refine my sketch to a contour line drawing.

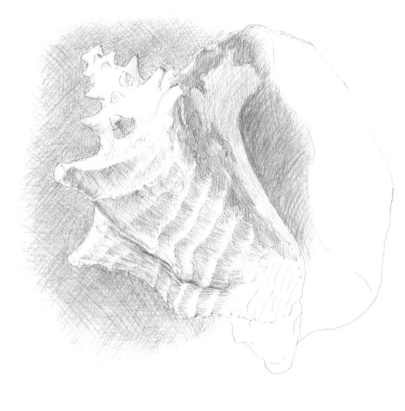

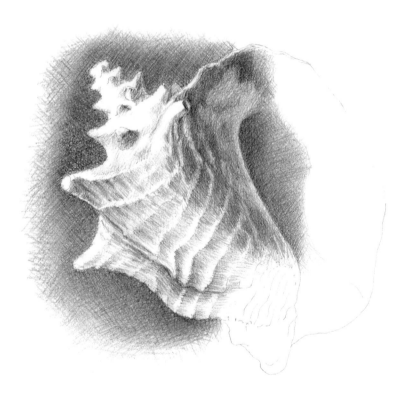

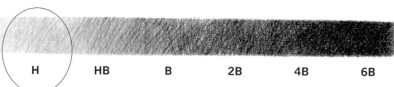

| H | HB | B | 2B | 4B | 6B |

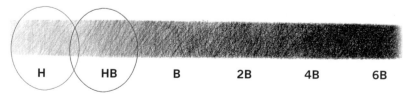

| H | HB | B | 2B | 4B | 6B |

2 I lay a foundation with a "wash" of H graphite over the entire area, except for the lightest or completely white areas. If I am unsure of how light a value should be I leave it white, knowing that I can always add more value to white areas later if needed.

3 Next I develop value with a specific application of my next darkest pencil—an HB.

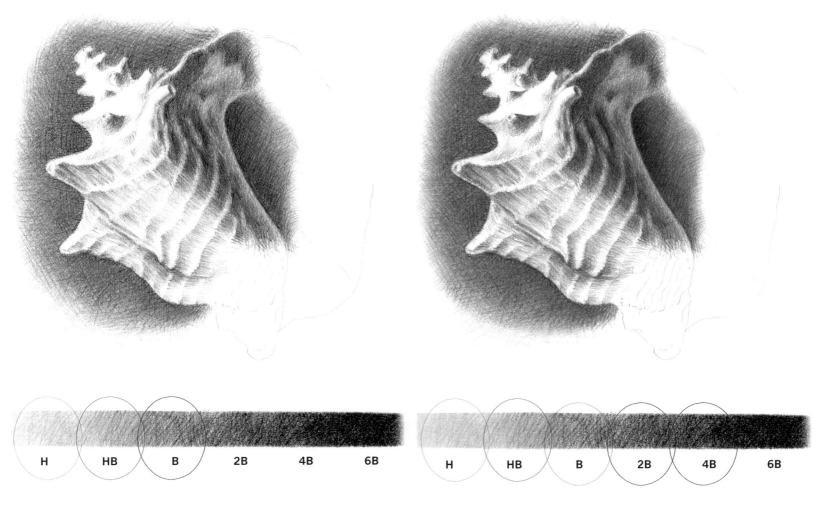

4 Next I apply a layer of B pencil over the two previous tonal applications. It's important to note that a large portion of the overall time spent on this type of drawing is in laying a foundation of tone with the lightest pencils. As you progress through the range of light to dark pencils, you'll spend a significantly smaller portion of time on each successive darker layer.

5 I add darker values of 2B and 4B pencil over the deeper areas of shadow and the background. I use a 6B pencil to accent a few of the deepest darks.

Reflective Surfaces

Light has various effects on different types of surfaces—something the artist needs to keep in mind in representational drawing. Reflective metal surfaces tend to have much stronger value contrasts than their surrounding environment. These strong reflections can become abstract in regard to recognition, but they always follow certain rules of lighting and contour over the form. Glass has certain consistent qualities of reflection and transparency that demand keen and careful observation. The demonstrations that follow offer an overview of some of these challenging situations. Practice and follow along in your sketchbook.

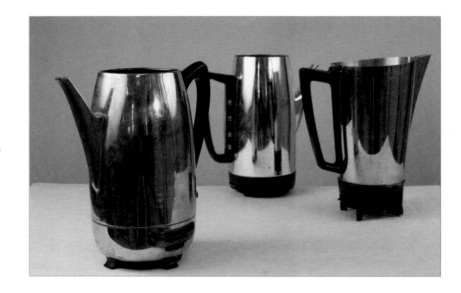

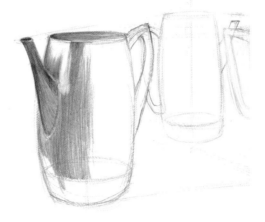

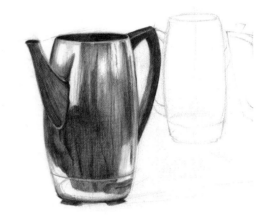

1 I start with an initial line drawing of one of the coffeepots, using an H pencil for the gestural block-in and an HB pencil for the contour lines.

2 I apply an initial layer of H and HB graphite over the entire surface of the pot, except for the highlights. Highlights on chrome or reflective metal tend to be hard-edged and strong, as do all reflecting values from the surrounding environment.

3 I apply successive layers with B and 2B pencils to bring out the highly reflective appearance.

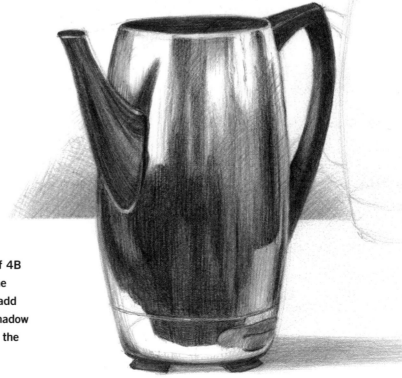

4 I apply a final layer of 4B and 6B graphite in the darkest areas of the pot and add background value and cast shadow to bring depth and solidity to the scene.

1 This underlying gesture drawing and contour line drawing took about 30 minutes to complete.

2 I use an H pencil to establish the transparency and overall pattern and direction of the reflections, as well as the background.

3 I continue the tonal development of the wine bottle with washes of HB and B graphite. I develop the lightness of the raffia in a linear direction to mirror its straw-like texture.

4 I use a 2B graphite pencil extensively, mostly on the background and darker reflections in the glass. Since the background is viewed through the glass, the reflections need to be darker than the background and lightened where appropriate with a kneaded eraser. I apply the last layers of 4B graphite and use a 6B pencil in the darkest shadows.

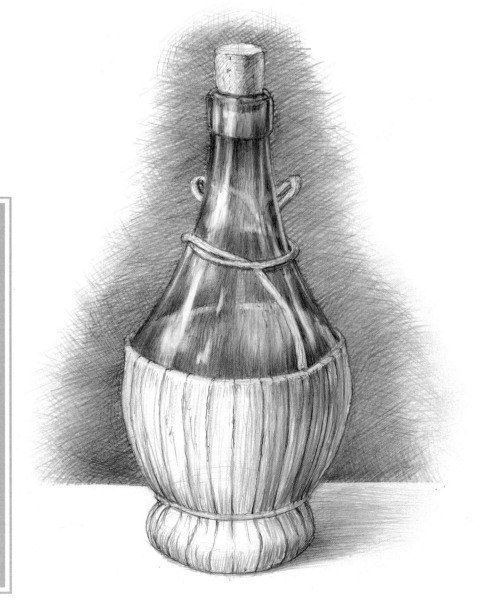

ARTIST'S TIP

When rendering glass, the background and glass object should have similar tonal consistencies for believable transparent quality. Overall, the glass should be slightly darker in value (not including dark and light reflections) than the background that is viewed through it, which is essentially seen through two layers of glass!

How to Construct a Grid

When working from a photograph as a reference, it's important to be able to enlarge the drawing based on the photo and maintain accurate proportions. One of the best ways to achieve this is to use a grid; one grid is the same size as the photo, and the other grid is an enlarged proportional copy for the drawing. The size that you wish to enlarge the new grid copy to has no limits. It can be as large as you want it to be.

There are several variations on a grid system, including mine. Most grids involve the use of squares covering the surface of the reference, and then enlarging each square proportionally for the drawing. This type of grid is accurate, but can be tedious to construct and to draw from, as each square must be numbered on all four sides and the re-drawing process involves matching numbered coordinates.

My variation is simpler and is based on geometry, and there are no numbers that must be coordinated. This grid brings back sketching into the process in a much more fluid and organic way.

Here is the photograph that my student used as a reference for an extended graphite drawing.

1 First make an enlarged, black-and-white photocopy of the reference, on which the grid can be drawn. The enlargement can be anywhere from a standard 8.5" x 11" page size up to 145 percent of the original photo. To begin the grid, start with marking a big "X" from corner to corner. It's helpful to use a colored pencil for the grid instead of graphite, which is difficult to see on a photocopy.

2 Next add the horizontal and vertical lines through the midline of the "X." Now the original size is divided into proportional fourths.

3 Now add smaller "Xs" to the upper and lower halves from the midline.

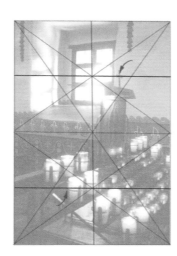

4 Add horizontal lines through the mid-point of the halved "Xs."

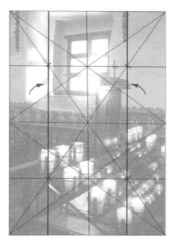

5 The last two lines are vertical and bisect either vertical half of the grid. The points of intersection from the previous drawn lines are shown here in green.

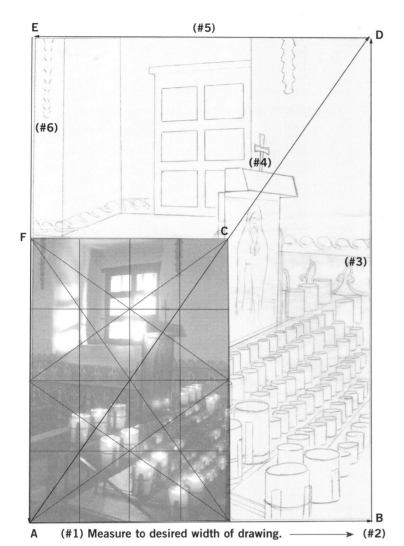

E (#5) D

(#6)

F C

(#4)

(#3)

B

A (#1) Measure to desired width of drawing. ⟶ (#2)

6 Tape the grid onto your drawing paper (or a large piece of tracing paper to transfer to art paper later). From point A at the bottom left corner of the photocopy, draw a continuous line to whatever width you wish the drawing to be (point B). Then, from point B, draw a vertical line almost to the top of your paper. Now draw a diagonal line from point A through point C, extending the vertical line from point B. The point where the diagonal line from points A to C intersects the vertical line from point B is the proportional height for your drawing (point D). From point D, draw a horizontal line across to point E, and then draw a vertical line from E back to point A (#6). Now you have an enlarged proportional format for your drawing.

Here is the enlarged grid with the finished contour line drawing. (Preliminary drawing by student Jarek Creason.)

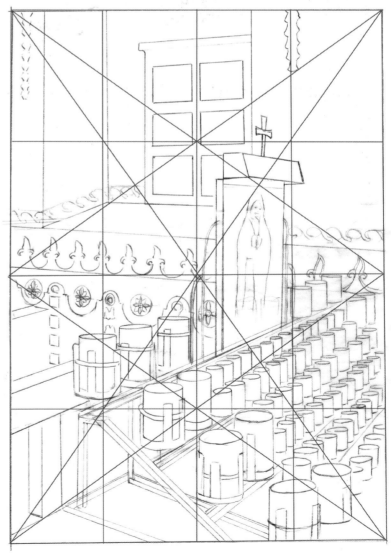

ARTIST'S TIP

Whenever possible, I encourage my students to develop their tonal drawings with a combination of hatched and crosshatched line work. This technique provides more energy and a higher level of sophistication to the work than blending with a stump or other method. Blending is easier to accomplish, but it does not bear the same craft-like quality. It is important to remember that these are drawings—and they are meant to look like drawings, not photographs! So, even when copying references from photographs, remember that the work is created by the artist's hand—your hand—not a machine.

YOUR HOMEWORK

Your homework for this chapter is an exercise in value development, with a range of at least five different grades of graphite pencils that will create value gradients from very light to very dark. A brown paper bag may seem like a fairly easy and simple subject, but it lends itself very well to tonal development.

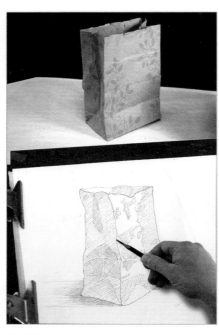

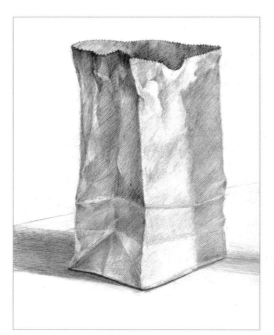

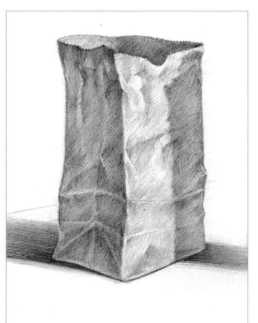

1 Find and set up a brown paper bag—the older and more used, the better! This subject contains interesting facets and folds, with a wide range of values and value changes, both subtle and sharp. Start with a gesture drawing. Then map out the overall shadow changes in light contour line.

2 In my drawing, I cast the shadow from another bag (outside of the picture plane) onto the lit surface of the bag, for more value variety and interest. Use a single light source to illuminate your bag, creating the highest contrast possible with the placement of the light source. Begin to create value with washes of H and HB over all the shaded and shadowed surfaces, leaving the white of the paper for the lightest areas.

3 Continue to develop values with your chosen range of graphite pencil gradations, from light to dark. Add subtle washes of the lightest grades of graphite to any white areas of the bag as needed. Don't forget to add the cast shadow and, if desired, background value.

Ink Line & Tone Application

In this chapter on ink drawing and ink tonal application, we will discuss techniques and tips that I believe will make the entire ink drawing experience a more pleasurable one—for both the beginning student and the seasoned professional artist. Drawing with ink does not have to be the dreadful experience that some think that it can be. With a few adjustments to the viscosity of the ink—and practice with a variety of pen nibs— ink can become as comfortable a drawing tool as graphite is. Ink can create a bold statement of the highest contrast; yet it can just as easily generate the lightest, most delicate washes possible in a variety of gradations. Again, as always, practice in this medium is the key to consistent, successful drawings.

Ink

Aside from carving in stone, ink is probably the most permanent of art media. Permanent India ink lasts as long as the paper on which it is drawn. This permanence can be intimidating for artists of any skill level; however, it does not need to be.

Ink has been used as a communication medium for thousands of years, and its versatility in print and the world of art makes it a medium that any artist should attempt to be comfortable with. It takes patience and practice to work successfully with ink, but the results are well worth the effort.

Organic subjects like this collection of exotic dried flowers are ideal for the beginning student's introduction to ink line drawing. Hard edges and straight lines can be avoided and replaced with long, flowing organic lines that offer the opportunity to gain confidence with the medium.

A common misconception about ink is that it is too heavy and black and difficult to draw with. I suggest that students dilute black India ink with a ratio of approximately 3 or 4 parts ink to 1 to 2 parts water. Part of an ice cube tray works well as an ink reservoir when using a diluted mixture, as the depth of the well allows most of the pen nib to be submerged into the ink.

Adding water to ink directly out of the bottle gives it more flow, but doesn't dilute it enough to affect its velvety black appearance.

The smaller the pen nib, the finer the line will be. To achieve very light lines for gesture drawings, simply add more water to the mixture. I prefer to use a larger nib, such as a B3, to sketch in gestural preliminary drawings; rounded nibs tend to flow across the paper, as opposed to fine-point nibs, which can be "scratchy" in a quick sketch. I recommend you save finer points for detail line work toward the end of the drawing.

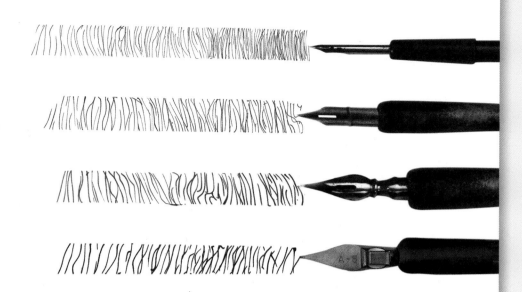

▶ Even a small selection of nib sizes and types can produce a variety of lines and mark-making.

Appreciation for the Past

There isn't much of a difference between the type of pen nibs that are used today and the classic nib and holder used in centuries past—from illuminated manuscripts of the Middle Ages and the Renaissance to Rembrandt, Goya, Van Gogh, and the Golden Age of Illustration. I feel it is important to introduce these artists and make their work relevant to my students so that they may appreciate the skills, understand the potential, and reinterpret the usage of this timeless medium for a modern era.

Ink Line Mark-making

It's important to understand the different types, sizes, and uses of a variety of ink nibs and points, which can create a multitude of marks on paper. Using a variety of different line weights and line textures will make any drawing more interesting and compelling. In this student piece, notice the detail of line-weight variety and mark-making employed.

Student drawing by Christie Tseng.

Creating Tone with Dots

One way to create tonal variation in ink drawing is with a technique called "stippling." To stipple means to create tone out of an accumulation of dots created with the point of a pen. To create a true dot, the pen nib should be held completely perpendicular to the paper, depositing the ink as a point without dragging it into a line.

While stippling is time-intensive, this technique is favored for its ease in creating gradual tone and value changes.

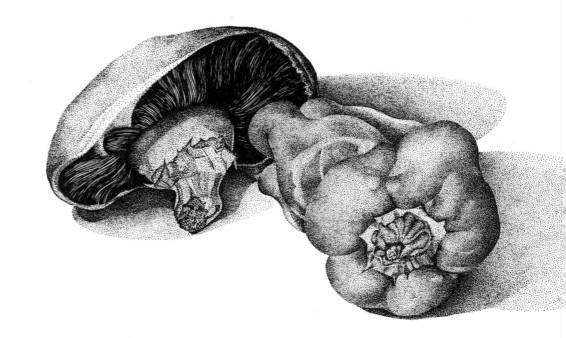

Above is an ink stipple value scale. A variety of values can be accomplished by adding more dots of ink placed closer together or by changing the size of the nib to create larger, darker dots.

Creating Tone with Line

Creating tone with ink can also be accomplished with line, or linear mark-making. The line can be hatched (one direction), crosshatched (multiple directions), or scribbled to create tone.

Creating a value scale with linear marks is a vital way to understand how to add techniques to an artist's "toolbox" and create interesting and complex drawings.

This type of tonal application can be employed for a variety of subjects, including still lifes, portraits, and architecture. The combination of crisp, clean ink marks with a variety of subtle-to-strong application techniques makes this linear mark-making a versatile way in which to build a successful value drawing.

This student's architectural drawing incorporates line and value with ink nibs and brush. Time: 12–15 hours.

Create a line value scale using hatching and crosshatching with various ink nib sizes for value development from light to dark.

Creating Tone with Washes

Another way to create tone with ink is to dilute the ink in various shades of gray, from very light (lots of water) to very dark (less water), and apply the resulting washes with a brush.

The types of brushes most often used for this purpose are very soft and absorbent natural-hair brushes, such as squirrel or beaver. (The hair for these brushes is humanely harvested, and the brushes are inexpensive.)

**An example of four washes used in an ink line drawing.
Time: 1 hour.**

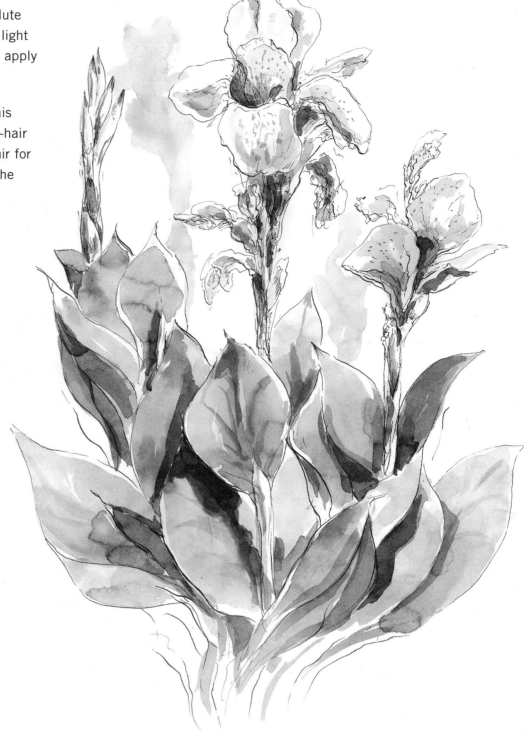

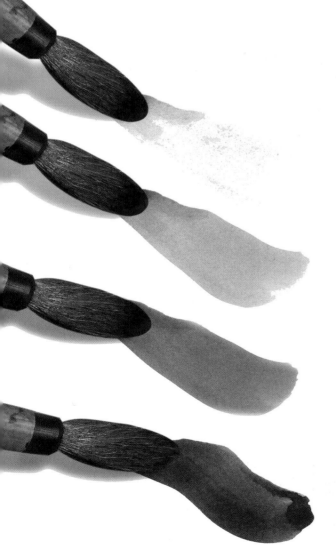

Brush quality is important, as the chemical constituents in ink can be harsh on brush fibers. Avoid using expensive brushes with this technique. As is the case with any tonal technique, it is important to first create a value scale in order to get a feel for the appearance of the ink wash and its application.

Experiment with the water/ink ratio until you achieve four distinct values from light to dark. With four washes, plus the white of the paper and the straight black ink from the bottle, you will effectively have six different values to work with.

YOUR HOMEWORK

In this homework exercise, you'll have the opportunity to practice all the elements that we discussed in this chapter. Gather two to three different types of flowers—real or artificial—and bundle them in a vase or hang them on a wall with fishing line. Use a single light source for illumination. Create a light gesture sketch, followed by a contour line drawing. Add a tonal wash application of four distinct values, from very light to very dark, with a brush. This exercise should take 90 minutes to 2 hours to complete.

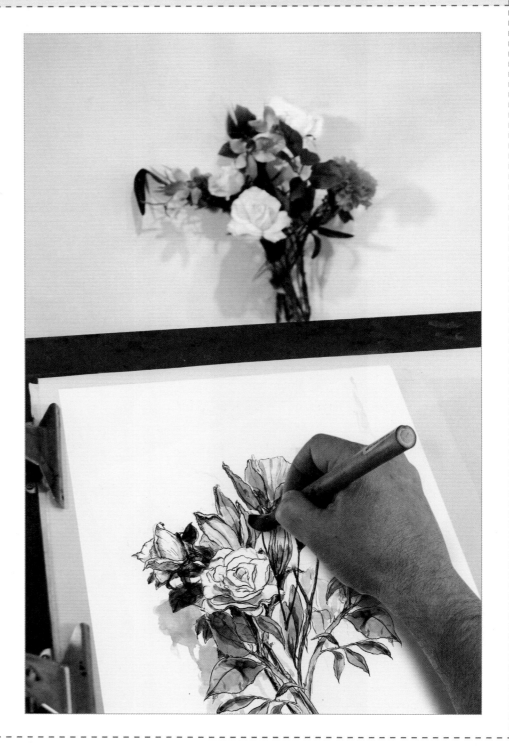

Charcoal

Charcoal is one of the most versatile drawing media available, capable of rich, velvety darks, easily achieved midtones, and subtle shading differences. It is an easy medium to learn, albeit messy—and there are ways to control that characteristic. In tonal drawing media, charcoal is at the forefront. A full range of tonal values can be developed much faster and easier with charcoal than with graphite. Unlike graphite, charcoal also lends itself very well to blending with a cloth, stump, or even a finger.

We have already discussed the term *chiaroscuro*, which describes the appearance of strong, high-contrast lighting on the subject matter. Using chiaroscuro effects in a drawing add a strong sense of volume to the subjects and create a sense of mood and drama. Charcoal is the ideal medium for creating a high-contrast, dramatic drawing that epitomizes the meaning of chiaroscuro.

Cast Drawing

In these first few techniques we will focus on creating chiaroscuro effects on white or off-white subjects, as this is the easiest and most direct way to view the play of light across a form.

A tonal drawing from cast sculpture is a great introduction to using charcoal to indicate the tonal range across a fully lit form. Cast sculptures can be found and purchased online, as well as from local statuary stores. Set the statue up in a semi-darkened room with a single strong light source. Light cast from a 45-degree angle is usually more dramatic than direct lighting from above.

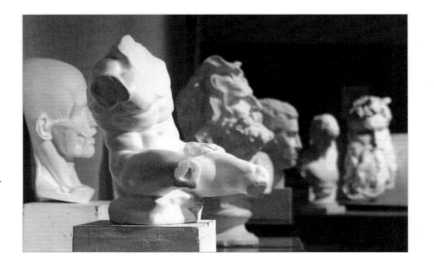

Remembering that all good drawings start with an overall gesture sketch, begin by considering composition, placement on the page, size, etc. Small thumbnail sketches at the outset are a very valuable tool for composing and cropping the subject (A).

Once the gesture drawing is lightly sketched in, refine the drawing for accuracy with a chopstick, checking the proportion, creating an overall linear envelope around the form to understand perspective angles, and lining up structures horizontally and vertically. This initial sketch can be developed with vine or willow charcoal and then strengthened and refined with charcoal pencil. I typically have my students work on layers of tracing paper so I can make suggestions and changes directly on their drawing (without affecting the final drawing). You may find it helpful to work on tracing paper as well, as you develop your skills, so that you can experiment with changes before committing them to your final piece.

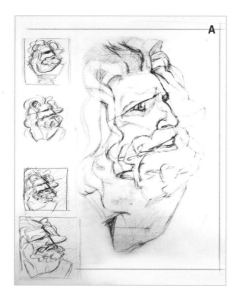
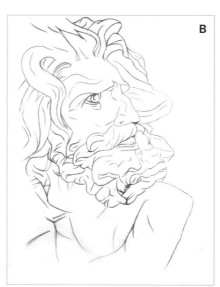
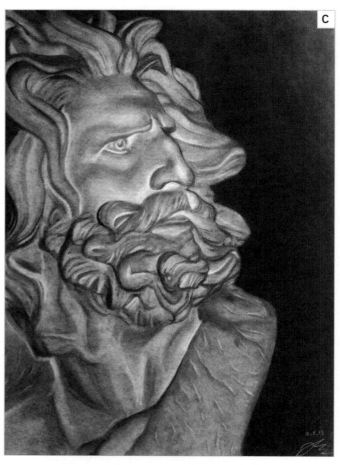

Once the sketch is refined on tracing paper, it can be transferred to a suitable drawing surface by rubbing charcoal over the back of the sketch and tracing the contour lines to transfer the line drawing to the drawing paper (B). (For transferring review, see the end of Chapter 4). After transferring a clean sketch to drawing paper, it is ready for tonal development (C).

Final charcoal drawing by student Huy Huynh. Time: 6-8 hours.

Demonstration: Cast Torso

The subject of this charcoal tonal development and technique demonstration is a cast reproduction of the Belvedere torso—a famous fragment of a human torso from the first century BC in Greece—from the Vatican museum in Rome.

Before we begin, lets review the important light, shade, and shadow information we discussed in Chapter 7.

Chiaroscuro depends on an understanding of direct light, transitional light to shade, core shadow, reflected light, and cast shadow. This is the lighting phenomenon that you see on the subject. Next let's discuss the actual application of charcoal to create this lighting situation accurately.

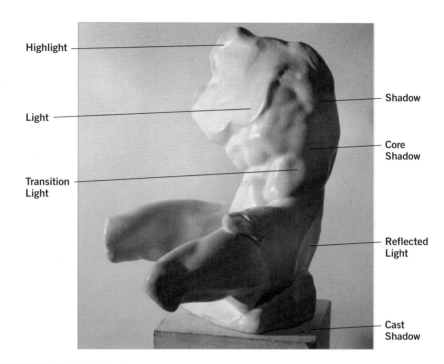

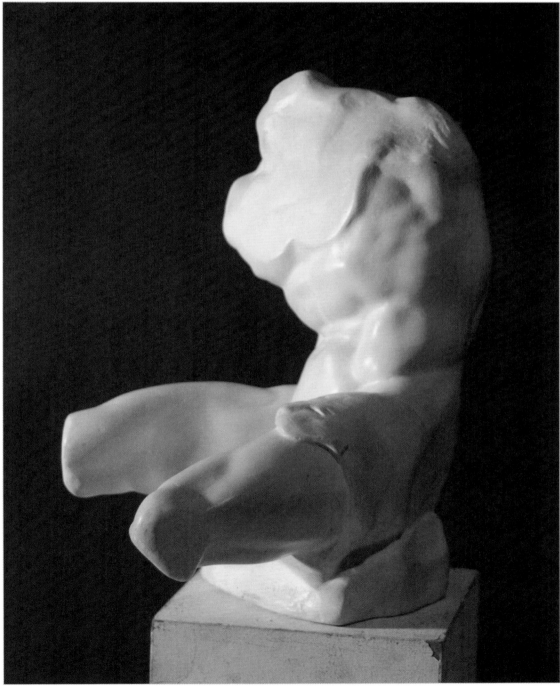

This is the same lighting situation as above, with the exception of a dark background. I chose this arrangement because it is more dramatic, and dark-value backgrounds are fairly easy to develop with charcoal, compared to most other drawing media.

Tonal Contrast

How we perceive the actual values of a subject depends on the contrasting relationship of values that are adjacent to it. The dark background for this cast statue creates more contrast between the subject and the background, as well as a low-key and dramatic lighting situation. Tonality is a relative situation, based on the effects of lighting and adjacent values. When you compare the statues on page 77, you can see the relative differences in the appearance of the values, especially in the shaded areas—particularly the core shadows, which appear darker in the statue with the lighter background.

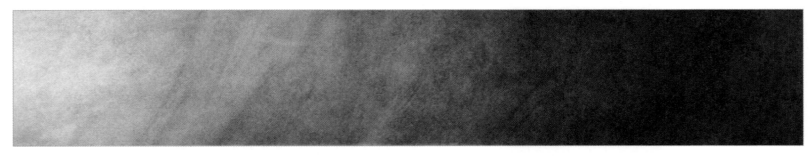

I used a variety of charcoal to create this scale from very light to rich, velvety black. From left to right: vine charcoal, compressed charcoal, and charcoal pencil, all blended with a chamois or tissue.

Tonal Techniques with Charcoal

Start with a value scale like the one above, using all the charcoal materials you plan to use in your drawing. In almost every tonal charcoal drawing, I use the same tools (see above), usually in the same order, for the best results. It's important to remember that using lighter to darker tools—and generalized techniques before details—is a key to success.

ARTIST'S TIP

The best way to fully understand the strengths and weaknesses of each material is to experiment. There are no set rules with these materials. You can use all of them, or leave some out completely. Most people work best when they have all these tools at their disposal, along with a logical progression in which to use them.

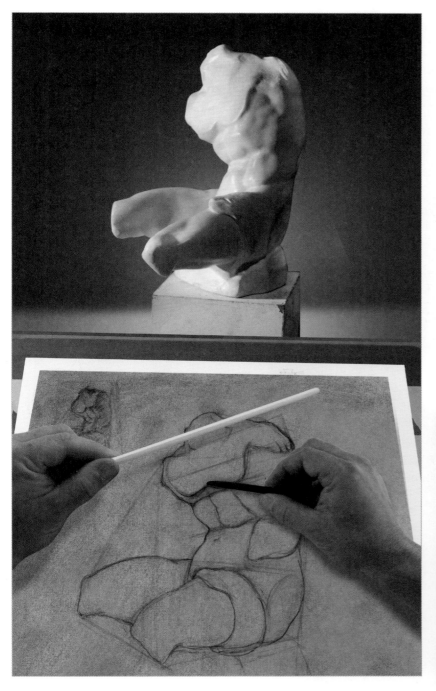

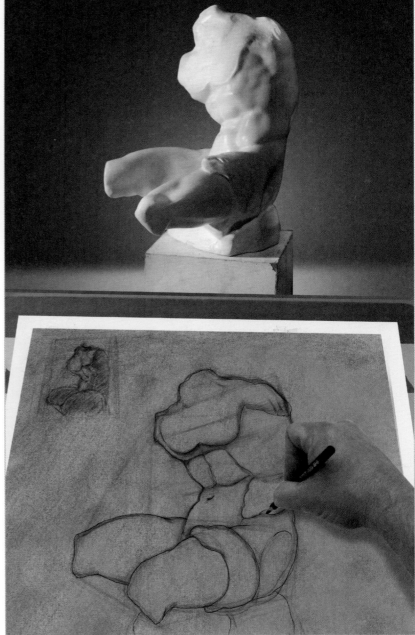

1 Tone the surface of white charcoal paper with vine or willow charcoal, stroking across the paper with the side of the charcoal. Then rub softly with a chamois or tissue. After sketching a small thumbnail in the upper corner, create an overall gesture sketch with a stick of vine charcoal, which is light, soft, and easily changeable. Use a chopstick for linear angles, horizontal and vertical alignments, and relative proportions within the torso.

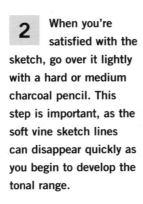

2 When you're satisfied with the sketch, go over it lightly with a hard or medium charcoal pencil. This step is important, as the soft vine sketch lines can disappear quickly as you begin to develop the tonal range.

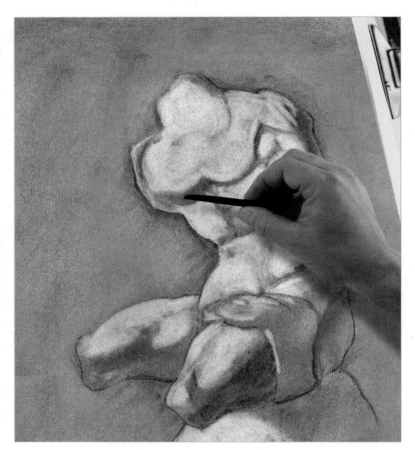

3 Next begin to pull out the generalized lighting on the form with a kneaded eraser. Don't attempt to achieve too much detail at this stage; it will likely disappear and need to be redone toward the end of the tonal process.

4 After pulling out the generalized lights, add in the overall shadows—the third value—with vine or willow charcoal.

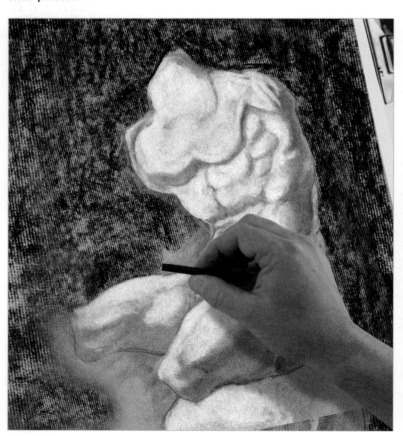

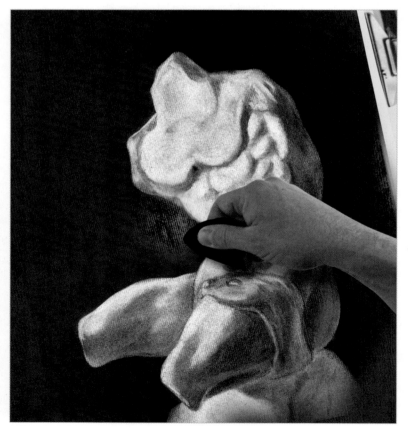

5 About mid-way through the tonal application process, it's a good idea to block in the background value, especially if it is a dark background. This makes it easier to judge the values within the subject. I suggest using a stick of compressed charcoal for this purpose, as it is darker and more permanent than either vine or willow charcoal.

6 Use a chamois to rub the charcoal into the paper for soft and even tone. Compressed charcoal provides a velvety, rich black. At this point, I suggest applying a light spray of workable fixative over the entire surface to help adhere the compressed charcoal to the paper.

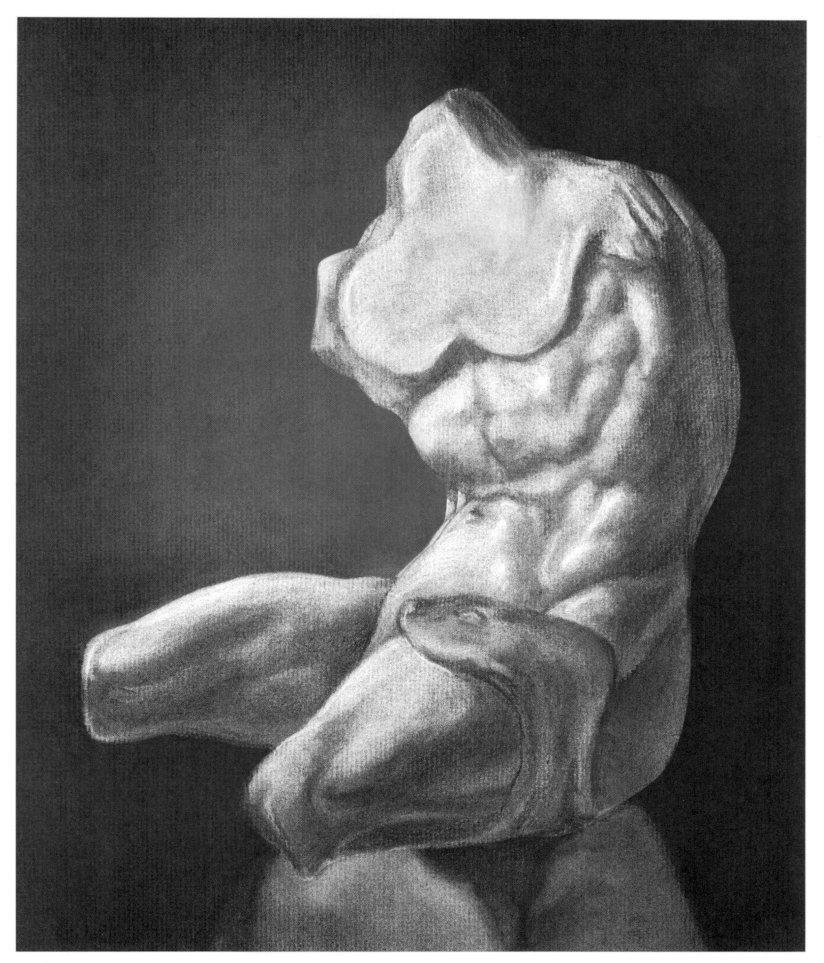

7 Apply the finishing touches. Clean up and refine the edges with a kneaded eraser. Then use charcoal pencils (soft grade), to create dark core shadows and cast shadows on the form. You can use a stump or tortillon to smooth the darker surfaces. Finally, use a white charcoal pencil sparingly to accent the lights and create highlights. It is best not to blend whites, as it tends to muddy them; use the whites conservatively, and leave them alone.

Additional Subject Matter

Still Lifes

In the still life composition below left, the shapes of objects are fairly simple, but the arrangement is complex. By this stage in your drawing education, you should be ready to take on more challenging compositions. Give it a try!

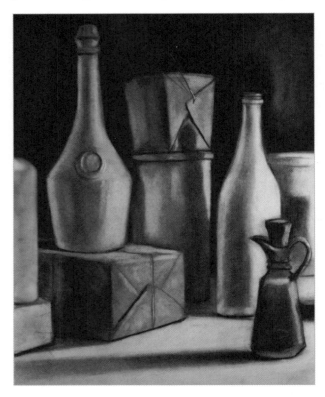

As you progress, you'll be able to approach more complex subject matter, with more value and texture contrasts.

Animal skulls—real or cast in plastic—are also good subjects for drawing white or light-colored objects, and they have a bit more texture and complex structure than cast statues. These also can be purchased online. The quality of some plastic skull replicas can be quite convincing, and the variety of sizes and animal types is vast.

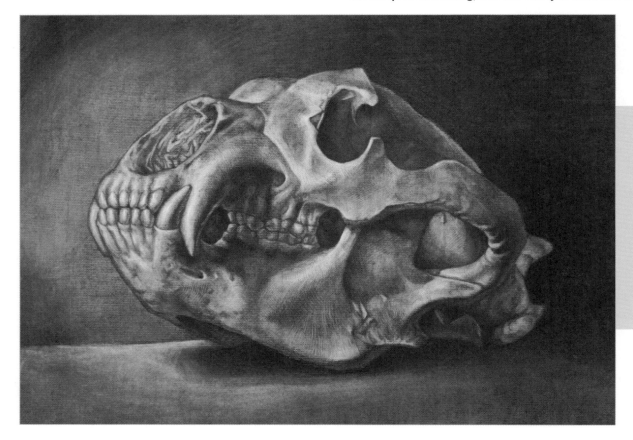

Student tonal drawing by Yea Jin Shin. Notice how the artist used crosshatching very effectively, with both charcoal pencil and white charcoal pencil. Time: 4–5 hours.

Figure Drawing and Charcoal

The speed at which the artist can attain a full value range makes charcoal a natural medium to use for figure drawing. Charcoal can be used for 1- to 2-minute gesture drawings, as well as intermediate poses of 20 to 40 minutes and, of course, for tonal drawings of longer duration. When used on toned paper, the addition of white charcoal for lights and highlights can be expedient as well as dramatic.

This is a 1-minute student gesture drawing in vine charcoal.

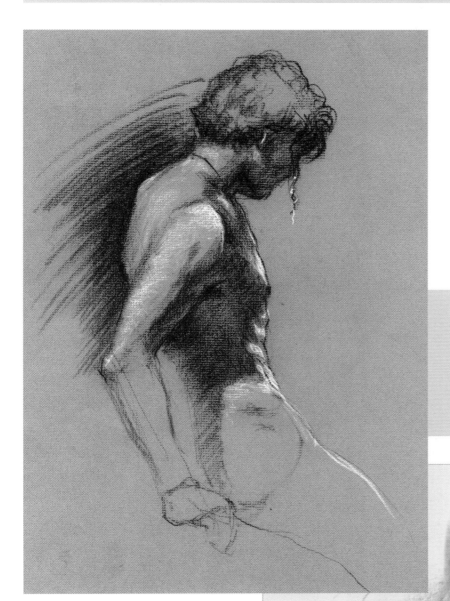

Here is a quick study in black and white charcoal pencil on toned paper. On this middle-value paper, the paper tone becomes the middle value for the softer shadows and reflected light on the figure. The use of white pencil is limited, as it can too easily dominate the value structure.

Charcoal has been used for centuries by artists wishing to portray the human body with dramatic form, mass, volume, and effective tonality. Student charcoal drawing by De Tran.

Conté Crayon

Conté crayons were invented near the end of the eighteenth century in France, and they continue to be used today—especially for drawing the human figure. Their warm, rich tones of sanguine, terra cotta, sienna, and black lend a unique tonal quality to a drawing that few other mediums can. Though waxier than charcoal, with a claylike feel, Conté crayons can be used like charcoal. This medium has hard edges that can be used to draw fine, semi-permanent lines, and it also has superior blending capabilities. Conté crayons come in sets containing several different shades of red and brown, as well as gray, black, and white. They are a very versatile and tactile tonal drawing medium that every serious drawing student should try.

Conté crayons typically come in a variety of earth tones historically related to the color of the soil in different parts of France. They contain a waxy binder that gives them a silky, smooth application and appearance. This range includes a very dark brown (bistre), as well as a very light, reddish orange (sanguine).

Copying the Masters

A great way to improve your drawing technique, with any medium, is to copy a Master drawing, working in the style of the Master artist. Working with the same tools and in the same style and line quality as the Master artist, you will learn to bring that type of quality, and perhaps spontaneity, to your own work. Conté crayon and charcoal are excellent media for replicating the type of tonality and line work used by the Masters.

Masters' reproduction drawings are a great way to be introduced to the techniques of the chosen artist. This is a reproduction of a page of anatomical drawings from Leonardo da Vinci's sketchbook on anatomy.

This is my interpretation of da Vinci's work in sanguine Conté crayon and Conté pencil for detail. Conté crayons had not been invented yet in da Vinci's time; he and other Renaissance Masters used various earth-based chalks and earth-toned inks.

This is a reinterpretation of the *Sketch of Five Characters* by Leonardo da Vinci. The student artist used bistre Conté crayon on cream-colored charcoal paper; the artist did not need to tone the paper with a chamois at the beginning of the drawing, as she intended to use hatching for value—just as da Vinci did in his original sketch. Student drawing by Pauline Huang. Time: 3-4 hours.

ARTIST'S TIP

Good choices for Master studies include artists such as Dürer, van Gogh, Seurat, and great Renaissance Masters Michelangelo, da Vinci, Raphael, and Rubens. You can find very good reproductions of Master works in the library or online.

YOUR HOMEWORK

Your homework for this chapter is to create a tonal drawing of an old shoe or boot, preferably white (or painted white) for maximum value contrast within the form.

Use the torso demonstration at the beginning of this chapter as a guide for the tonal development process.

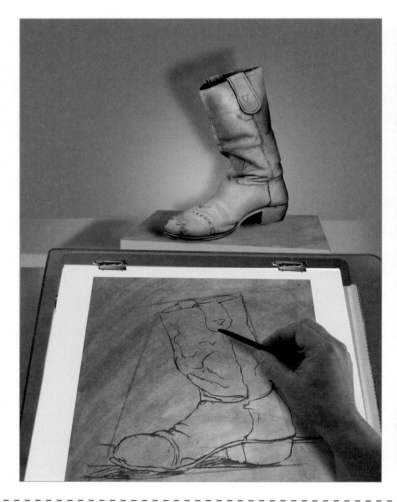
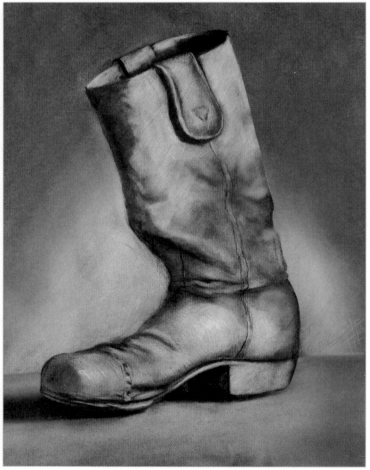

ARTIST'S TIP

A helpful recipe for achieving value balance in a composition is: a gallon of gray, a pint of black, and a tablespoon of white. This balanced light-logic recipe can be successfully applied to any lighting situation and adjusted for different values in the same ratios (e.g., a gallon of white, a pint of gray, a tablespoon of black).

Color

This chapter deals with two different drawing media: colored pencil and pastel. This is not meant to be a definitive explanatory chapter on color; it would take a whole book to do that well. This chapter is not meant to be a color theory or painting class, but rather a simple introduction to the beauty and pleasure that color can bring, as well as an introductory lesson in color application with drawing media. As we learned in the previous chapter, value can add *drama* to a drawing, and in the last chapter, we'll see how perspective is the *mathematics* of drawing. But in this chapter, we'll explore how color is the *magic* in drawing.

Colored Pencil

Colored pencil is a versatile drawing medium that can emulate watercolor, oil, or pastel effects. It can also be used successfully on its own or in conjunction with other dry media for high contrast, intense color, and value application.

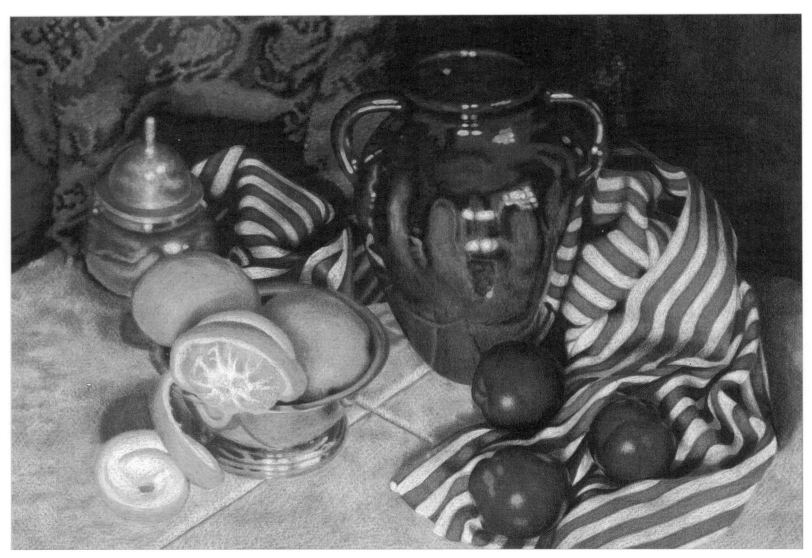

Student colored pencil drawing. Time: 12–15 hours.

I have found that the best and easiest way to develop high-contrast, high-chromatic drawings in colored pencil is to use gray marker as an initial value underpainting, with glazes of transparent and opaque colored pencil layered on top.

The precedent for this technique goes back centuries to a style of painting popular in Europe in the fifteenth and sixteenth centuries and still in use today—*grisaille*. The initial stage is a black-and-white, or umber-and-white, monochromatic underpainting. Thin glazes of transparent color are then applied for the middle value and shadows, and opaque colors are added at the end for light colors. This type of painting is usually referred to as a "glazed" painting.

Similarly, gray marker on gray toned paper acts as a monochromatic underpainting upon which transparent glazes of colored pencil can be applied, without a heavy buildup of wax—a key ingredient in most colored pencils. Too much waxy buildup on paper will limit the artist in the number of colors and layers that can be successfully used, which can be problematic when trying to build up color and value simultaneously with only colored pencil. By applying a marker underpainting, the value is already there, soaked into the paper without any changes in paper surface. You can glaze many separate colors over the marker without worrying about losing the paper's surface! At the end of the process, the brightest and lightest colors can be applied as strongly as desired with a technique called "burnishing," which involves laying down heavier pressure with the opaque light colors.

Working from Photographs

Working from photographs is almost always inferior to working from life, but they are a necessary, practical alternative whenever there are complex arrangements with living subject matter or when referencing outside subjects. The negative aspect of working with photographs is that key information can get lost in deep shadow. Additionally, light and bright colors can be "blown out," due to the insensitivity of a camera to low or bright lighting. Unlike a camera, our eyes can easily adjust to see light in dark shadows and interpret the accurate colors in any lighting situation. When working from a photograph, a thorough knowledge of the perspective structure of symmetrical objects can be very helpful. To paraphrase a noted plein-air painter, "Draw what you know, not what you see (or don't see)."

At the beginning of your learning experience, try not to work from photographs. But if you have absorbed all the previous lessons on composition, structure, perspective, and value, you should be ready to work from a photograph, especially if it is a good one. You may find that the more you use photographs for reference in your work, the less you will strive to make your work look exactly like a photo. Instead you will use the photo just as a starting point for your own creative and expressive artwork.

Mixed-Media Colored Pencil Demonstration

In this first demonstration of a still life of oyster shells, I will concentrate on the marker value application, which is really the foundation of most of the colored pencil drawings in this chapter. We'll take a closer look at colored pencil techniques in the second and third demonstrations in this chapter. I work on gray paper. As a rule, I avoid white paper because it takes much longer to achieve color buildup and requires lots of extra practice and skill.

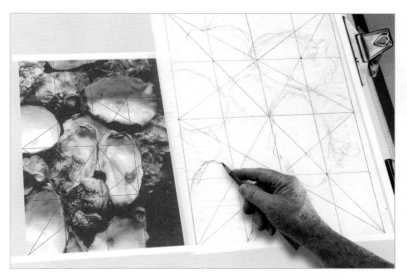

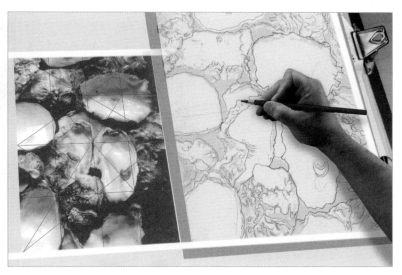

1 First I place a grid on the grayscale photocopy of my reference photo and a slightly larger grid on the paper for my initial gesture sketch. After quickly and lightly blocking in the forms, I refine each of the generalized subjects with stronger line.

2 I place a second layer of tracing paper over the initial gesture drawing and create a clean contour line layer for the transfer. To transfer the drawing to art paper, I rub brown pastel over the back of the drawing and smooth it with a tissue. Then I turn the drawing right-side up, tape it to the art paper, and redraw the contour lines. I suggest using a different color of pencil to trace the contour lines so it is easy to see what has been transferred.

ARTIST'S TIP

For working with a value range of markers, I recommend purchasing a limited number of markers,
for example 20%, 40%, 60%, 80%, and black (or 30%, 50%, 70%, and 90%). It isn't necessary to use
10 different markers to achieve a good range of values on gray paper.

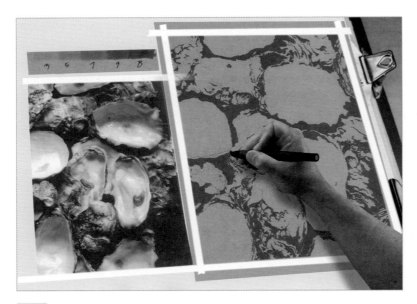
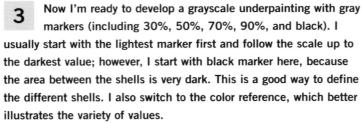
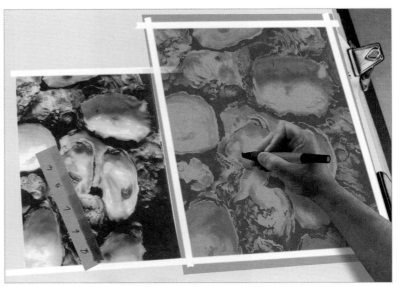

3 Now I'm ready to develop a grayscale underpainting with gray markers (including 30%, 50%, 70%, 90%, and black). I usually start with the lightest marker first and follow the scale up to the darkest value; however, I start with black marker here, because the area between the shells is very dark. This is a good way to define the different shells. I also switch to the color reference, which better illustrates the variety of values.

4 With the dark background established, I work from the lightest to the darkest values, with the paper being the lightest of the gray tones. I use a value scale, labeled "3" through "B" for black, which represents the percentage of the marker ink. My techniques for applying marker are varied, but I usually work in small circular strokes, which blend into the paper well.

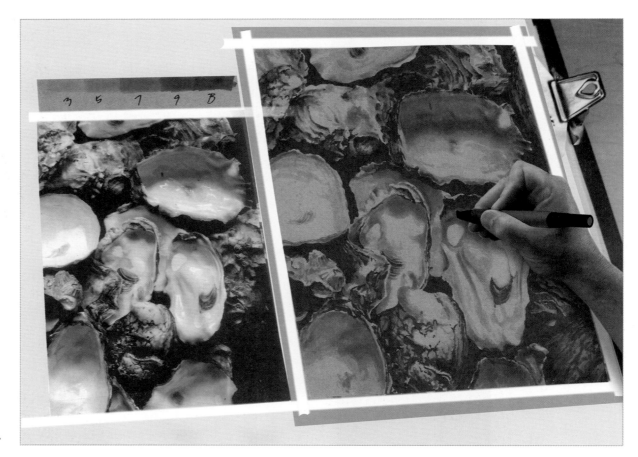

5 Next I use my darkest, 90% gray marker to finish the underpainting. Once you complete the last dark values, the amount of time spent with each marker will reduce dramatically. Be patient in these early stages. An underpainting like this may take two to three hours, but the results are worth the time spent.

ARTIST'S TIP

Working from light to dark with markers is easier and more logical, as you can always go darker, but it's impossible to go lighter. Basically, you are building up any value that is the same as your paper value or darker. Colors or values that are lighter than the paper can be accomplished with colored pencil.

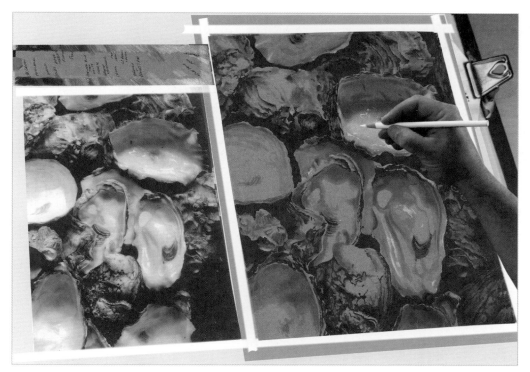

6 With the underpainting finished, I start the colored pencil application. If there are strong highlights, I usually draw them first, so I don't have to worry about whether there will be enough paper surface at the end to accept them. Eventually, every inch of the drawing will be in colored pencil, with no visible marker on the surface of the finished artwork. However, the value applications, especially the darkest values, make their presence known in a substantial way.

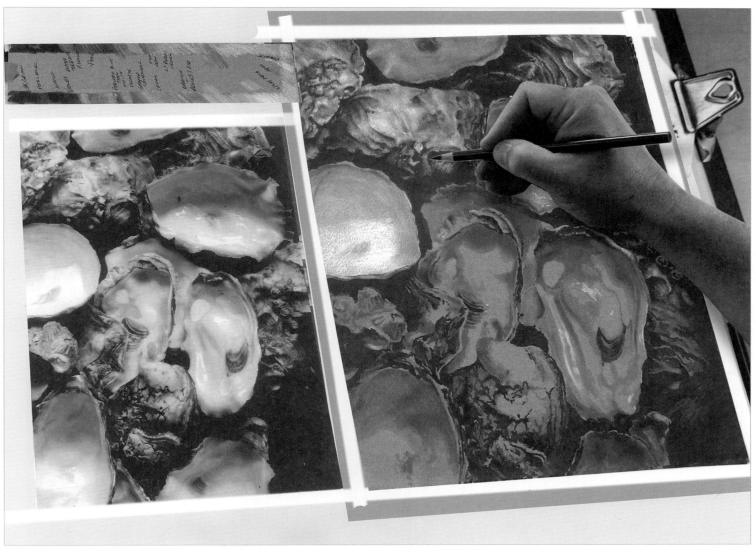

7 As I progress through the color development process, I usually start with the light or middle colored pencils first and work up to the darkest colors to make sure that there will be enough paper texture for the lightest and brightest colors.

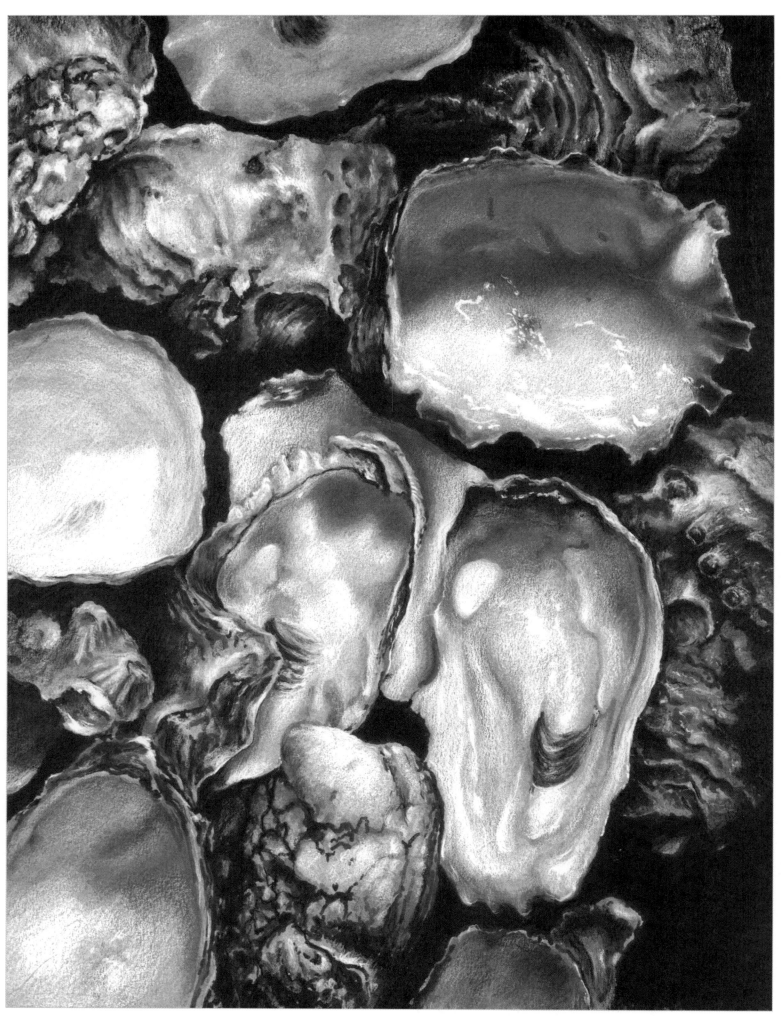

The final colored pencil drawing. Time: 8 hours.

Color Application

This second demonstration focuses on colored pencil application techniques, which can be used with or without marker and on white paper or a toned surface. I typically work on gray or neutral-toned art paper to get the most out of the brighter colors. You may also find that it is more difficult to develop dark values on white paper. I recommend starting the color build-up process from light to dark, with plenty of paper surface left at the end for the strongest, lightest, and brightest colors. There are always exceptions to any rule, but I have found that this method is usually the most successful.

1 After sketching and transferring the drawing and creating a marker underpainting, I begin applying color, working from light to dark.

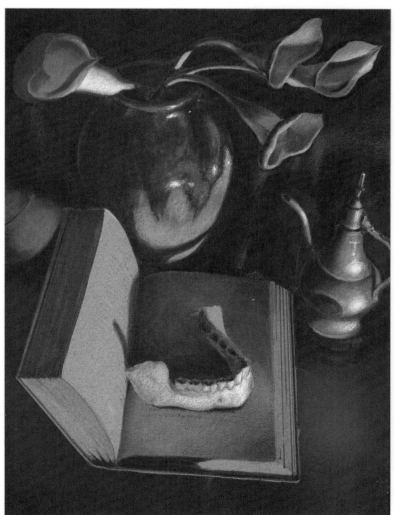

2 I lay on initial glazes of color in most still lifes from light to dark, planning to return to each object later for refinement and contrast.

ARTIST'S TIP

There is no singular "best" technique for applying colored pencil to paper. Sometimes you may want to use hatching and crosshatching. For smooth surfaces or a gradient, I use circular strokes. To cover large areas, I use sandpaper to soften the tip of the pencil before applying. For maximum color application without heavy pressure, I keep the point very sharp.

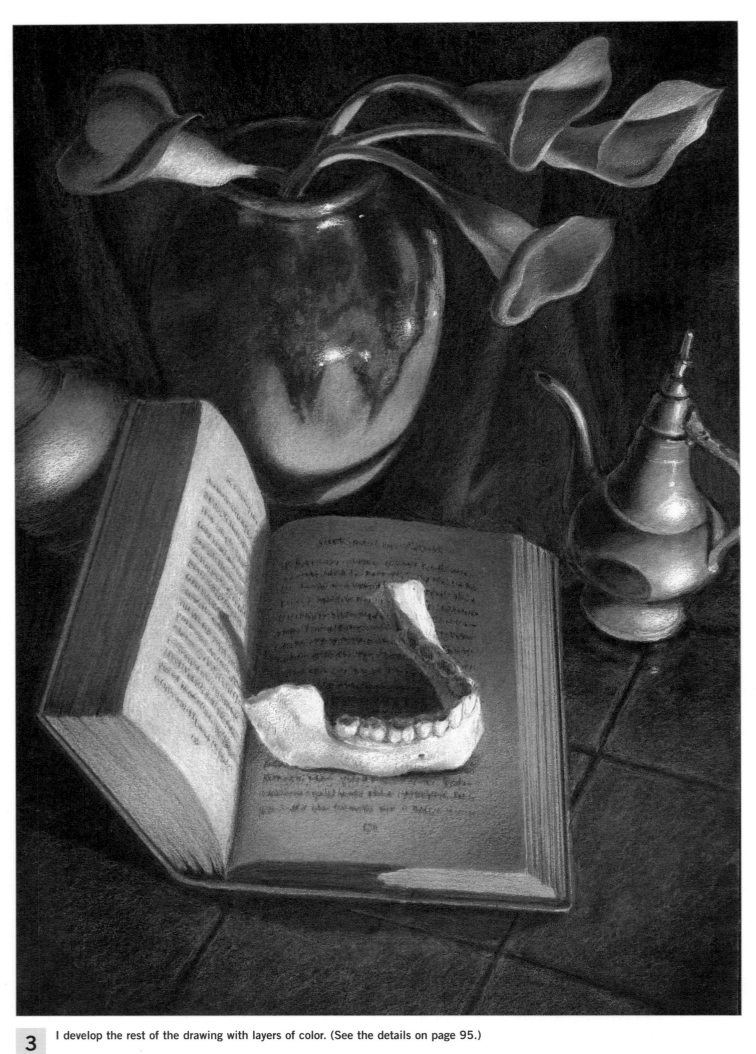

3 I develop the rest of the drawing with layers of color. (See the details on page 95.)

FLOWERS DETAIL I develop the flowers with a light layering of cream, pink, and red, in that order. I don't use heavy applications; each layer is softly developed into the last with light circular, rotating strokes. I want soft gradations of color and value. For the shadows, I use combinations of Tuscan red and black grape pencils.

DRAPE DETAIL To render the background drape, I start with the middle color, blue violet. Then I use indigo blue for the deepest shadows. I finish with a light cerulean blue, using very soft pressure, because I only need a small amount of highlight on the dark cloth. It's easy to correct overdone highlights by softly applying a middle color to tone it back down.

TILE DETAIL I develop the tile with light circular strokes of color, starting with muted turquoise and following with espresso and dark umber. To render the brass pot reflection, I use the same colors that I originally used on the brass pot, but with much less pressure and a glaze of espresso over the reflection.

Burnishing the Brightest Colors

In this seashell demonstration, I focus on the finishing burnished highlights. In a drawing such as this, I want to save plenty of paper surface for the brightest colors. I use a felt-gray Canson paper—the smoother of the two sides—which still affords plenty of necessary texture.

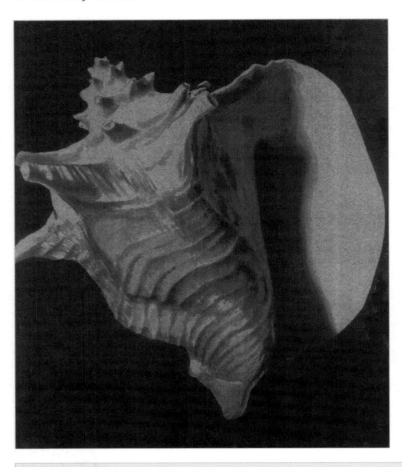

◄ The initial value underpainting took me 60 to 90 minutes to complete.

Burnishing

Colored pencil catches in the tooth of the paper; therefore the layers can appear rough. For a smooth, shiny effect, burnish the layer by stroking over it with a colorless blender, a white colored pencil (to lighten), or another color (to shift the hue) using heavy pressure. Burnishing pushes the color into the tooth and distributes the pigment for smooth coverage.

It is always a good idea to create a value/color scale before starting an extended drawing. This will help solve any glazing or layering problems before the process starts. A student, who was kind enough to make a color copy for me, created the colored pencil value chart below. Notice that she even added marker values for comparison.

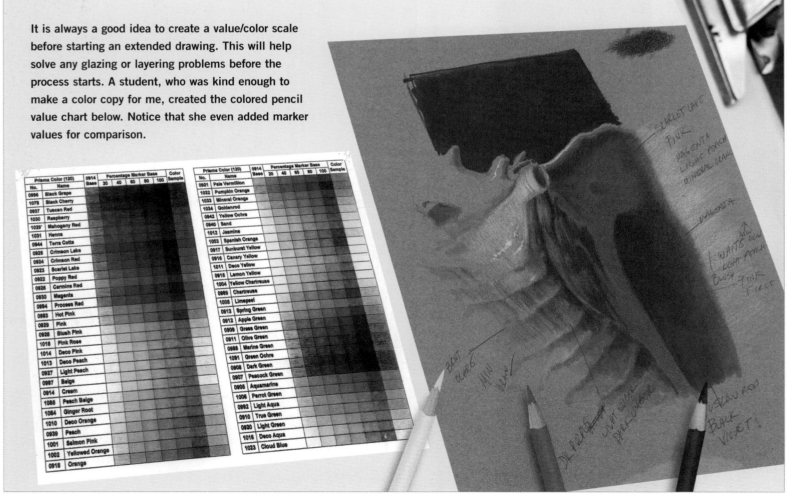

Prisma Color (120) No.	Name	0914 Base	Percentage Marker Base 20 40 60 80 100	Color Sample
0996	Black Grape			
1078	Black Cherry			
0937	Tuscan Red			
1030	Raspberry			
1029	Mahogany Red			
1031	Henna			
0944	Terra Cotta			
0925	Crimson Lake			
0924	Crimson Red			
0923	Scarlet Lake			
0922	Poppy Red			
0926	Carmine Red			
0930	Magenta			
0994	Process Red			
0993	Hot Pink			
0929	Pink			
0928	Blush Pink			
1018	Pink Rose			
1014	Deco Pink			
1013	Deco Peach			
0927	Light Peach			
0997	Beige			
0914	Cream			
1085	Peach Beige			
1084	Ginger Root			
1010	Deco Orange			
0939	Peach			
1001	Salmon Pink			
1002	Yellowed Orange			
0918	Orange			

Prisma Color (120) No.	Name	0914 Base	Percentage Marker Base 20 40 60 80 100	Color Sample
0921	Pale Vermillion			
1032	Pumpkin Orange			
1033	Mineral Orange			
1034	Goldenrod			
0942	Yellow Ochre			
0940	Sand			
1012	Jasmine			
1003	Spanish Orange			
0917	Sunburst Yellow			
0916	Canary Yellow			
1011	Deco Yellow			
0915	Lemon Yellow			
1004	Yellow Chartreuse			
0989	Chartreuse			
1005	Limepeel			
0913	Spring Green			
0912	Apple Green			
0909	Grass Green			
0911	Olive Green			
0988	Marine Green			
1091	Green Ochre			
0908	Dark Green			
0907	Peacock Green			
0905	Aquamarine			
1006	Parrot Green			
0992	Light Aqua			
0910	True Green			
0920	Light Green			
1016	Deco Aqua			
1023	Cloud Blue			

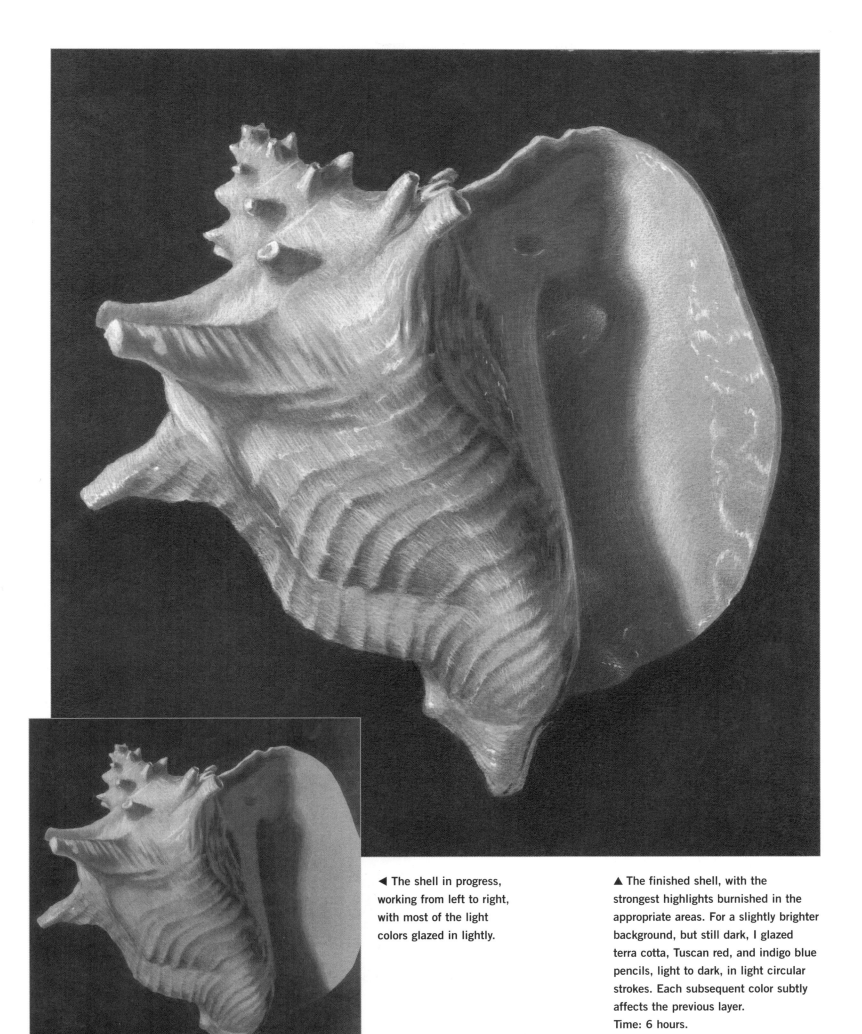

◀ The shell in progress, working from left to right, with most of the light colors glazed in lightly.

▲ The finished shell, with the strongest highlights burnished in the appropriate areas. For a slightly brighter background, but still dark, I glazed terra cotta, Tuscan red, and indigo blue pencils, light to dark, in light circular strokes. Each subsequent color subtly affects the previous layer.
Time: 6 hours.

Monochromatic Artwork in Colored Pencil

When not working from a color reference or subject, I have found that black, white, and neutral colored pencils can be a great way to produce high-contrast, dramatic drawings.

Black colored pencil on a more textured white art paper, such as Bristol vellum or stipple paper (also known as coquille paper) is an effective, expedient way to build up a wide range of values without the need to layer different grades of graphite pencil. The rich, black, matte appearance of the black colored pencil is also a plus.

Conversely, white colored pencil on black illustration board or art paper can be as dramatic and beautiful as any typical drawing. The amount of pressure used with the pencils, as well as the textured surface of the paper, is a key factor, as is the sensitivity of the artist to the effects of light on the forms.

A combination of black and white colored pencils on gray-toned paper is also a logical and effective way to build up dark and light values efficiently and quickly, with the neutral paper acting as the middle value. For this type of drawing—and for varying types of subject matter—I use gray paper values from about 30% to 50% on the value scale, all the way up to 80% and even, occasionally, black paper.

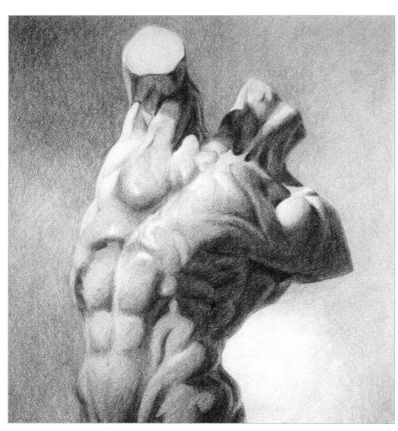

This torso was rendered with black colored pencil on white stipple board. The textured and pebble-like surface lends itself to creating a good range of values with black colored pencil, using a variety of pressure-sensitive strokes. Student drawing by Jason Slavin. Time: 6–8 hours.

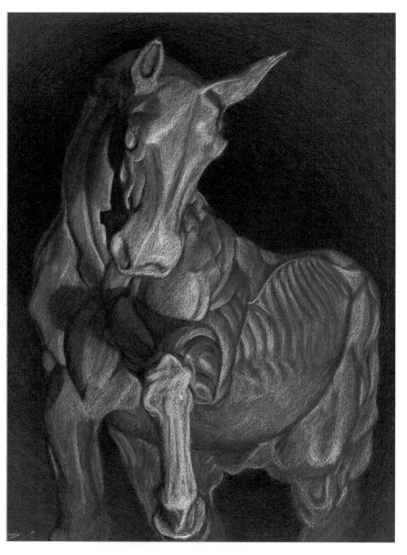

For this dramatic tonal drawing on dark Canson paper, black and white pencils were supplemented by subtle additions (as desired) of cream and dark umber pencils, which act as a subtle bridge for the white and black colored pencils, respectively. Student drawing by Huy Huynh. Time: 6–8 hours.

YOUR HOMEWORK

This homework project can be created using an actual still life or a color photograph of your choice. Choose a still life to render in colored pencil.

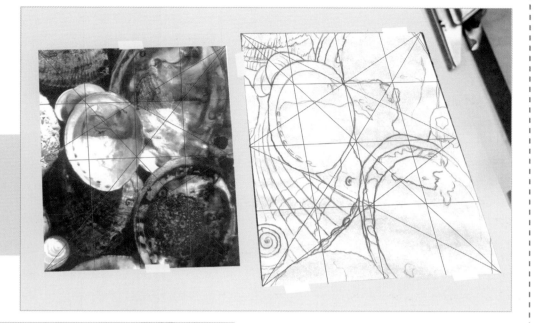

I like working with the iridescent colors of abalone shells; find subject matter that you prefer, but look for strong color and value choices in your subject.

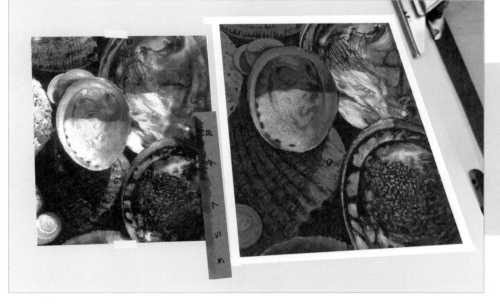

If you're working from a photo, try using the grid method to transfer a line drawing to art paper. Add marker value, with ranges of 20% to 80% and black, or 30% to 90% and black. Use a value scale for value development and a color-swatch scale for color development.

Try to work in the size range of 14" x 17" to 16" x 20" for your final drawing.

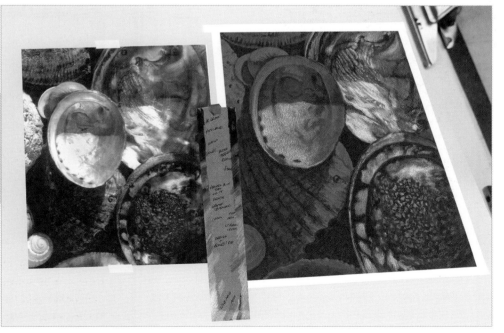

Pastel

Pastel is another color drawing medium that I introduce students to when they are ready for more of a challenge, and hopefully, a reward. Pastel lends itself very well to bold strokes of color, as well as subtle blends in value, color, and edge variety. Pastel is the softer side of color drawing media, with little to none of the hard, waxy binders that give colored pencils their hardness and permanence. Pastels range from just a bit softer than colored pencil to soft and buttery, easily crumbling to the touch. I prefer pastels somewhere in the middle. In this section, I will discuss techniques using both pastel sticks and pastel pencils.

▲ Student pastel drawing by Yea Jin Shin. Time: 6–8 hours.

Similar to my use of colored pencils, when working with pastel, I like to use toned or colored paper, from a 50% value to darker, for dramatic, bright colors. I prefer to work on sanded pastel board, which, though expensive, can make a big difference in the success of the project. With pastel and its relative softness, the more texture the paper has, the better.

Pastel Pencil Demonstration

For this demonstration, I am using a reference photo taken at the Huntington Museum and Gardens in San Marino, California. I wanted to capture the time of day and the lighting of the season, just before sunset—when the fleeting, soft January sunlight is about to fade into blue and violet shadows. Similar to colored pencil application, after an initial block-in of dark values/colors, I start with middle values and work up to darker colors, saving the lightest and brightest colors for the end. Other than the initial underpainting, I only blend with strokes of the tip or the side of the pencil, one color against or over another. I prefer to work as the Impressionists did, with pure colors playing off one another, without the tendency to overblend.

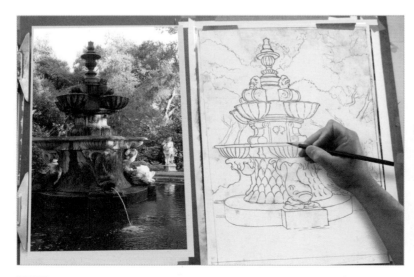

1 I transfer my drawing onto a sheet of dark green, sanded pastel paper. To transfer, I rub a dark pastel stick on the back of the drawing, tape it upright onto the pastel paper, and redraw the image.

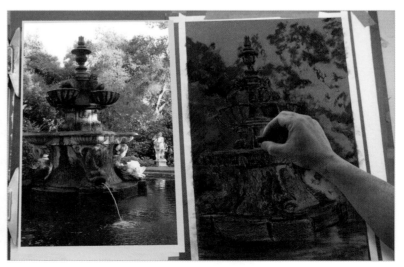

2 In my initial pastel application, I use a large stick of soft pastel to create the dark shadow areas in the trees and on the fountain. I use large strokes of dark blue and black for the fountain and dark green in the trees.

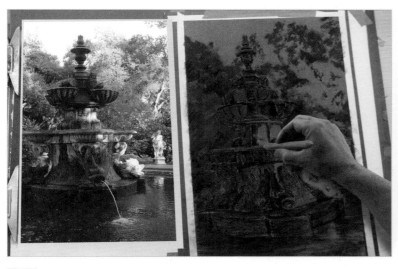

3 I want to work these dark colors into the surface of the paper, so I use a clean stump to blend. Then I spray several light coats of workable fixative over the surface to really adhere the dark colors into the paper. I want successive layers of lighter and brighter colors to stay clean and avoid muddy blending from the undercolor.

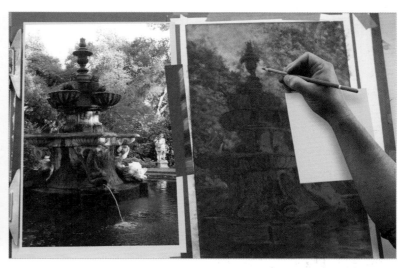

4 I generally work from top to bottom in order to avoid smearing any of the color that I have applied. I also recommend keeping a piece of paper under your hand while working. Here I build up initial layers of color in the trees and sky with strokes of color from pastel pencils. The only blending of color from this point on will come from pencil strokes, not from a finger or stump.

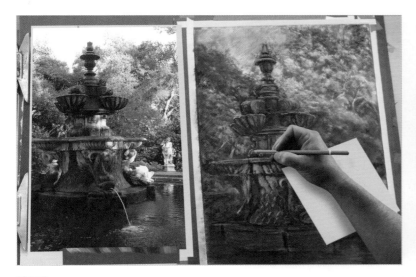

5 Working down the drawing, I add brighter colors to the shadowed areas of the fountain. I use 6 to 8 different colors of greens, blues, and browns in these shadows alone!

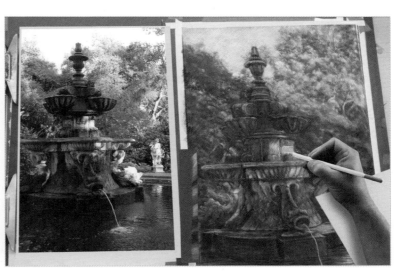

6 After establishing the values of most of the shadows on the fountain, I can more clearly judge how bright, or how subtle, the sunlight should be.

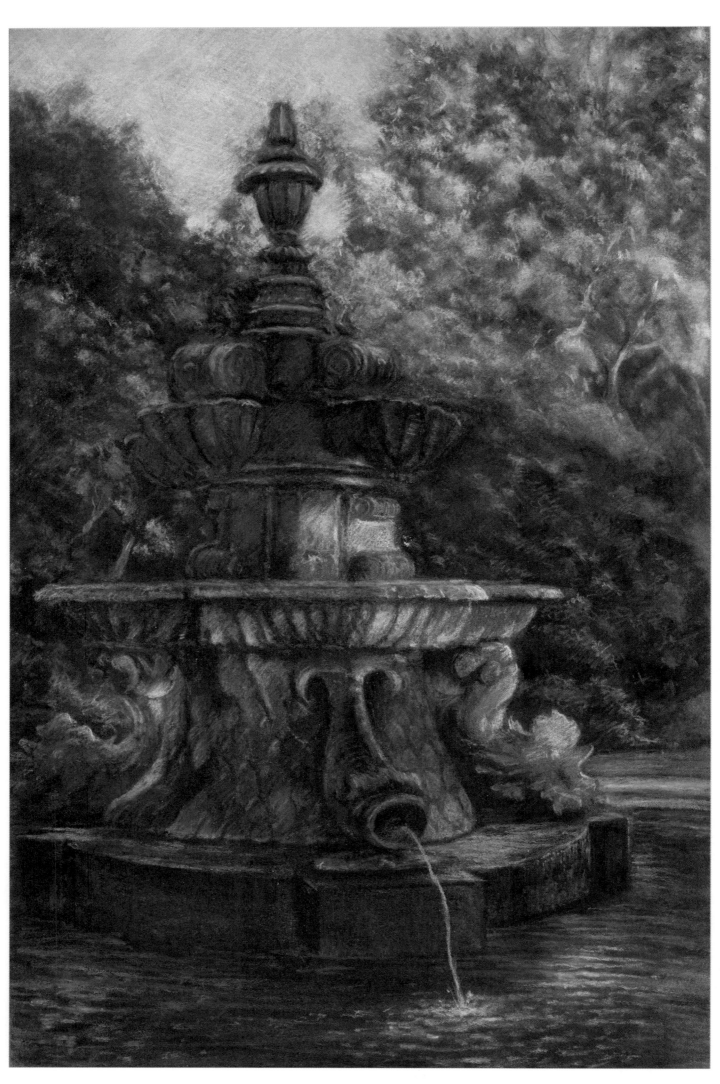

The final
pastel drawing.
Time: 8 hours.

Pastel Stick Demonstration

I have chosen an idyllic autumn scene for this demonstration. My work is influenced by the work of California Impressionists, both contemporary and past artists, and I want students to experience this joyful, artistic impulse to colorfully and creatively capture the color in the world around them. Even though this demonstration is not a true "plein-air" work created outdoors, I want to give it that spontaneous feel. For this reason, I chose to render this subject with pastel sticks.

1 After using a grid to create the line drawing, I transfer it onto medium-gray, sanded pastel paper. I drag a stick of red pastel lightly across the paper's rough surface for tone and apply several coats of workable fixative to adhere the color. I don't want the red to bleed into my subsequent layers, but I do want it to unify the drawing, as well as add an interesting complement to the bright colors that will follow. On top of the red background, I add dark colors of blue violet and black to shadow areas.

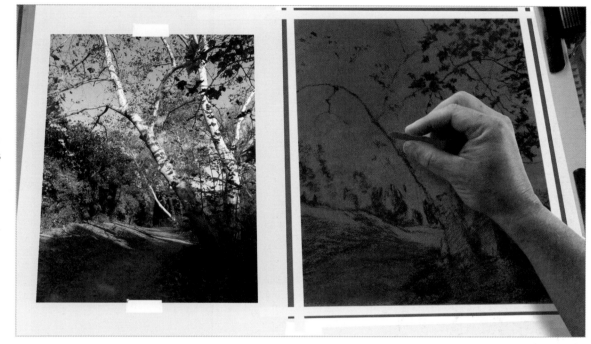

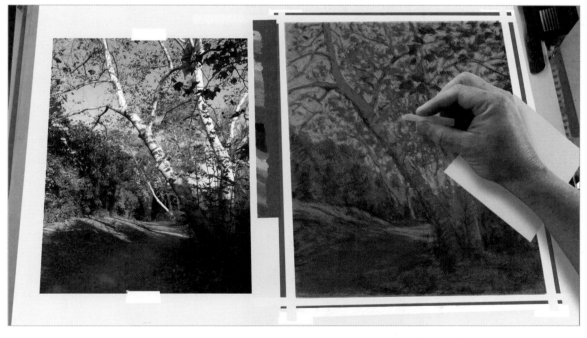

2 I blend the dark colors into the paper with a large stump and apply several more light coats of workable fixative to seal them into the paper surface. Establishing the value and color of the sky is an important element in any landscape drawing or painting, as a daytime sky is usually the brightest value. I will eventually use three different blue pastels in the sky, from lightest near the horizon to a middle-value at the top.

Pastel Stick Tips

- By nature, pastel sticks do not have the detailed and precise application capabilities of pencils. They are best for laying in large, bold areas of color, using the side of the stick.

- For more direct application, you can use the tip of the stick, making pastel sticks relatively versatile.

- Avoid blending, and allow the edges of adjacent colors to visually blend. This is great for creating soft and hard edges, as well as mixing in a third color.

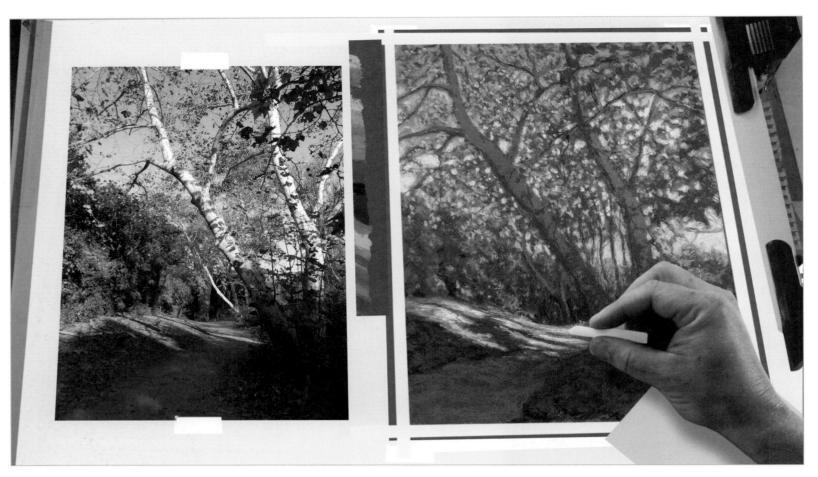

3 Once the sky and background trees are blocked in, I start to develop the sunlit areas on the path and around the two foreground trees. The process for pastel color application is different than with colored pencil. In this case, I start with the darkest color in any particular area and work up to the lightest colors at the end. Here I finish the sunlit area with bright cream.

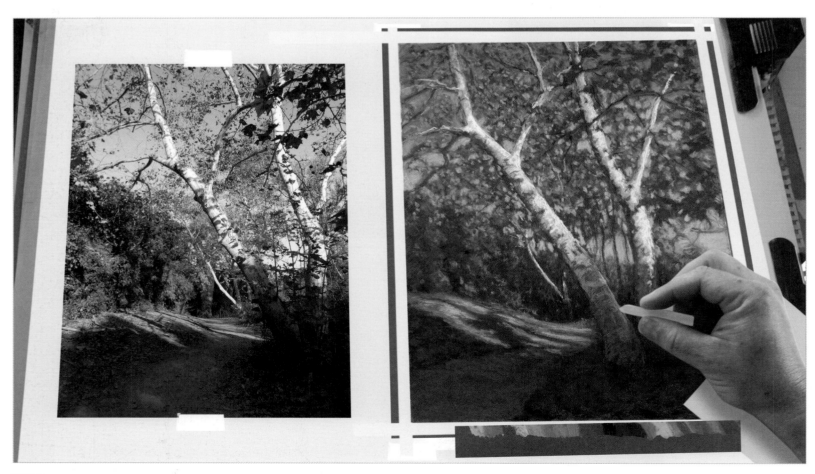

4 The main focus for this drawing is the bright trunks of the sycamore trees. I saved these for last so I could best judge the colors and values in both the sunlit and shadowed areas. In the shadows, I add subtle violets and warm neutral colors over the dark values beneath.

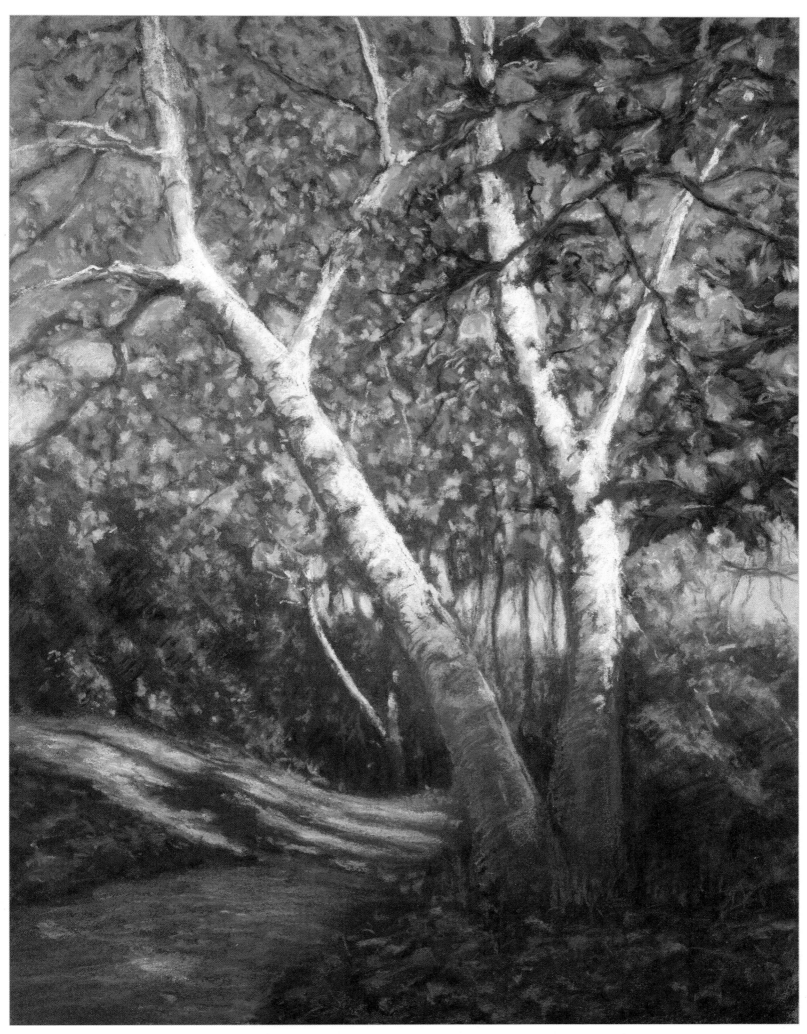

The finished pastel drawing, "El Dorado." Time: 8 hours.

YOUR HOMEWORK

Using any landscape or floral photograph, create a contour drawing, and transfer the drawing to quality toned art paper—preferably one designed specifically for pastel. Then experiment with the techniques that I demonstrated in this chapter for pastel sticks and pencils. Work in the size range of 14" x 17" to 16" x 20" for your final drawing.

Photo reference and pastel drawing by student Huy Huynh. Time: 8 hours.

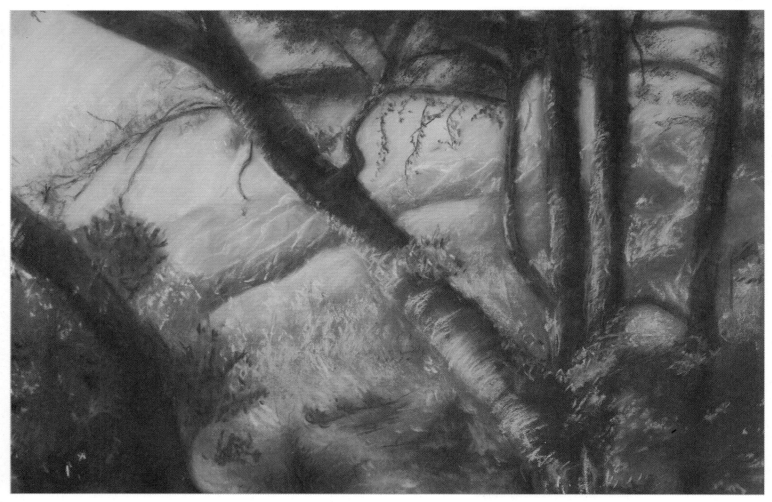

Linear Perspective

Previously we have discussed the picture plane, eye level, "table-top" perspective, and perspective terminology, giving us a basic understanding of one- and two-point perspective. In this final chapter, we will go into more depth on perspective as it relates to observation and drawing architecture—both interior and exterior.

A perspective class was the first class I taught when I began my teaching career—probably because they couldn't find anyone who wanted to teach the subject! I was young and eager and thought that I knew everything I needed to know about perspective—or at least enough to teach a foundation class on the subject. Was I ever wrong!

I needed to learn more, so I immersed myself in the subject, reading every book I could find on perspective. Over the years, I have been able to distill most of my acquired knowledge into a lesson plan, based on what I feel the average general art student needs to know. Understanding perspective theory—and how to apply it—will help you create strong, accurate spatial drawings.

Principles of Perspective

For centuries prior to the Renaissance, artists struggled to portray the world around them with an accurate depiction of spatial dimensions, usually with little or no success. Just before the Renaissance, several artists (among them, Andrea Mantegna and Tommaso Masaccio) discovered clues to solving the mystery of where lines and edges converge in a depiction of deep spatial dimension. The main discovery was the vanishing point and the theory behind it, which states that lines and planes converge to a point or points on the artist's eye level, based on the artist's viewpoint.

To truly understand the logic of perspective, you need to start with eye level. Eye level and the horizon line are one and the same. Eye level is the viewer's perspective—the way things appear at the viewer's level of observation. If the viewer changes his or her height by climbing up a staircase or sitting on the floor, the perspective view changes as well. Eye level is always horizontal, never at an angle. *Note: Eye level/horizon line is portrayed as a horizontal red line here and in all further illustrated examples.*

There are a few other consistent principles inherent in all perspective situations:

Convergence is the appearance of parallel lines, planes, or edges coming together toward a common point as they retreat from the viewer.

Size diminishment means objects or structures of the same size appear to get proportionally smaller as they retreat in space from the viewer.

Foreshortening means the sides, tops, and bottoms of objects seem to become narrower and flatter as they move away from the viewer.

FORESHORTENING As planes of the same size move away from the viewer, they become narrower and flatten as they recede.

VANISHING POINTS Lines or planes recede into in the distance to a mutual point(s). Vanishing points are always on the horizon line (eye level).

CONVERGENCE Lines or planes that are parallel to each other appear to converge, or come together, as they move away from the viewer.

SIZE DIMINISHMENT The posts and beams diminish in scale proportionally, as there is equal distance between each set.

Understanding the key relationship between eye level, also called the horizon line, and the vanishing point is crucial. Vanishing points are always on eye level. Later in this chapter we will discuss different types of convergence points, but true vanishing points are always on the horizon line. Vanishing points may not always be directly in front of the viewer, as is the case in a two-point perspective situation. Even so, always know that the angled edges of parallel and perpendicular planes (walls) are converging on perspective vanishing points that are always on the viewer's eye level.

Eye Level

Understanding where eye level falls is a key component to drawing in perspective. When observing and drawing an architectural subject, always know initially where true eye level falls. The example at right is of a very low eye level; the artist is sitting and drawing from the ground. Even if you're not sure exactly where the vanishing points are located, you can assume that they are on eye level.

Illustrated here is a normal eye level for most people. The sidewalks widen dramatically as they advance toward the viewer. The tops of doors and windows converge down toward the vanishing point on eye level; the higher the windows and rooflines, the more acute the angles become.

Here is the same view from several floors up. The eye level has changed and so has the perspective view. The sidewalk edges closest to the viewer are narrower and less foreshortened. Most of the window tops and bottoms on the building to the right are below eye level, so their edges converge up to the vanishing point on eye level.

When the eye level is elevated, as demonstrated near left, notice what happens to the angles on the rooflines, windows, and sidewalks. Once an artist understands the importance of eye level location, it's easy to spot inaccuracy in a drawing. Remember not to confuse line of vision with eye level. You can move your eyes up and down to see objects, but the true eye level stays constant.

The Picture Plane

As discussed in Chapter 3, the picture plane is an imaginary sheet of glass between the viewer and the subject. It is meant to represent your drawing board, and the viewer's line of vision should extend through it at a right angle. The picture plane, in theory, is facing exactly what you are drawing, which encompasses roughly a 60° circle around the viewer, which is called the cone of vision. If you find yourself turning your head to see what is on one side within that zone, you are basically turning your picture plane and your cone of vision, and there will be distortion in your drawing.

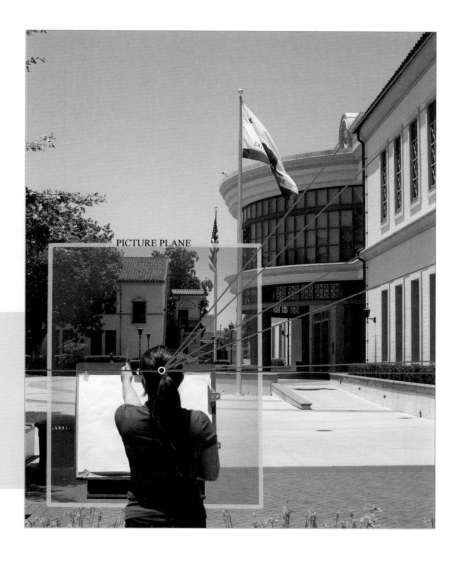

This is a one-point perspective situation. The back wall, or plane, of the far building is parallel to the picture plane. The vanishing point is directly in front of the viewer. The one-point perspective is apparent on the building to the right, which is perpendicular to the far building that is parallel to the picture plane. The tops and bottoms of this far building are horizontal, parallel to eye level.

One-Point and Two-Point Perspectives

If the wall or plane in the background of your view is parallel to the picture plane, or if the building that you are drawing is perpendicular to the picture plane, it is a one-point perspective situation. In this situation, the edges of the walls are parallel and vertical to the picture plane, and the top and bottom edges of the floor and roofing are horizontal.

Here is a classic one-point situation, with the back wall and arched opening parallel to the picture plane and the walls on both sides perpendicular to the back wall. Student perspective drawing by Jane James. Time: 8–10 hours.

This is also a one-point drawing, but the eye level is very elevated; the artist is sitting on a staircase somewhere around the second floor. To understand and portray this perspective, the artist must focus on a point directly in front of him or her on true eye level; otherwise, the drawing will not be accurate.

In two-point perspective, neither wall of a building is parallel or perpendicular to the picture plane. Lines, planes, and edges on each side converge to common vanishing points on their perspective sides. The only edges that are horizontal within this view are lines or edges that coincide with the horizon line.

In order to accurately portray the correct proportions of a building in two-point perspective, it may be that one or both vanishing points for the building are located beyond the limit of the paper.

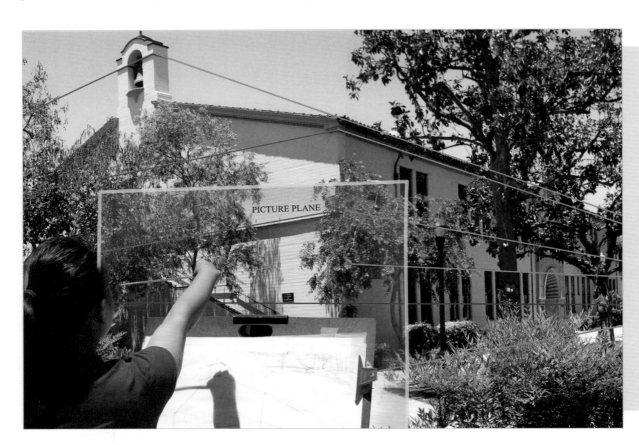

The main difference between one- and two-point perspective is that, in a two-point view, none of the planes (or walls) of the building are parallel to the picture plane. Think of this building as a large box that is tilted away from the picture plane. The edges of the walls on the right (green lines) converge to a vanishing point on the same side on eye level. The edges of the walls on the left (blue lines) converge to a vanishing point on the left side, also on eye level.

Here is what the line drawing of the building would look like to the artist looking through the picture plane. Notice the angles of the receding lines as they move away from horizontal (eye level). As the lines rise away from each other, there is a gradual change in the angles, culminating in the steepest angle at the top-most point of the building. Notice also that eye level is the same for all three people depicted in the image. The figures become proportionally smaller as they move further from the picture plane, but on a flat surface like this, their eye levels stay the same.

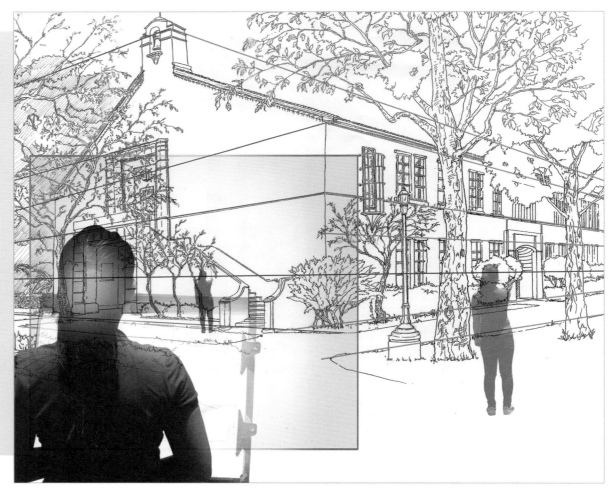

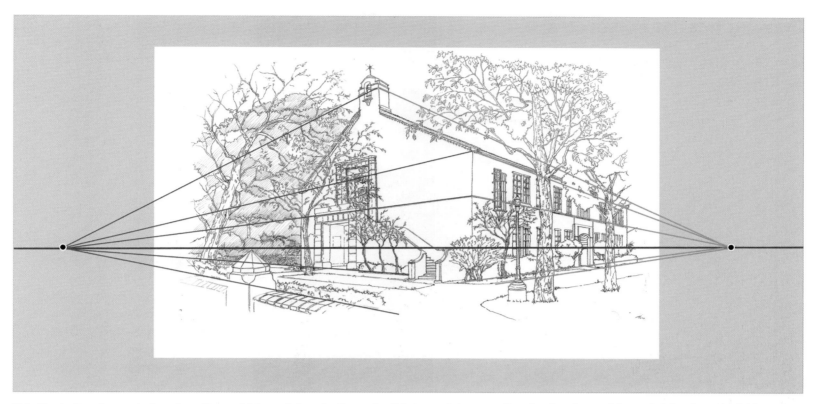

This illustration demonstrates where the vanishing points actually are for this two-point perspective drawing. In most two-point drawings, vanishing points fall off the page if they are drawn accurately.

Vanishing Point Exceptions

There are a few exceptions to the rule that vanishing points are always on the horizon line. These exceptions include lines that create inclined planes, such as staircases, rooflines, wheelchair ramps, etc. We'll call these convergence points *trace points* in order to separate them from true vanishing points.

Another exception to the rule is points of convergence for three-point perspective architecture, which we will not discuss in this chapter. The points of convergence for three-point perspective are known as vertical vanishing points. However, for our purposes in this chapter, one can reasonably expect vanishing points to always be at eye level.

Drawing Interior Perspectives

Drawing an interior perspective can be described simply as drawing the inside of a box, rather than the outside; all the same principles still pertain, with a few subtle differences.

A one-point interior: Remember that the picture plane is parallel to the back wall facing the artist, and we can see that all of the lines on the perpendicular walls converge directly to one vanishing point on eye level. Student perspective drawing by Stephanie De Roo.
Time: 4–5 hours.

First establish whether the view is a one-point or two-point perspective situation. If the back wall facing you is parallel to the picture plane, it is a one-point perspective. If none of the walls within your view are parallel to the picture plane, it is a two-point perspective. Always remember to find the eye level right away; if it is a one-point perspective, the vanishing point for the perpendicular walls will be directly in front of you.

A two-point interior: The picture plane (and the artist) have turned away from the back wall; the picture plane is now parallel to the corner of the room, and the artist's line of vision is directed at the corner of the room. The blue lines on the left wall, as well as any structural edges on or parallel to that wall, all converge to a common vanishing point on the right side of the drawing. Student perspective drawing by Charlene Yu.

The right-side wall and all structures parallel to it are represented as green lines that converge to a common vanishing point to the left side of the drawing. Again, look at the angles presented by the lines above and below eye level as they move away from horizontal. Student perspective drawing by Charlene Yu.

In the two-point perspective demonstrated above, you can see that the vanishing point for the left wall is within the picture plane, but the vanishing point for the right wall is well outside of the picture plane. In a two-point perspective drawing, it's a good idea to expect that neither vanishing point will be on the paper; but it's always a nice surprise when one of them is.

Two-Point Perspective Construction Demonstration

When we go outside as a class to do a perspective drawing from observation, I always demonstrate the process that I want my students to follow in order to successfully attain accurate linear perspective. It is a logical process that involves understanding the picture plane and how it is used, transferring accurate sight-size measurements of the subject to the drawing, and being able to accurately see and draw angles in perspective—even if there are no vanishing points within the drawing.

Remember the all-important rule when sight-size measuring. Your arm must always be straight when measuring for consistent proportional measurements. Follow along with the demonstrated steps as you work on your own drawing.

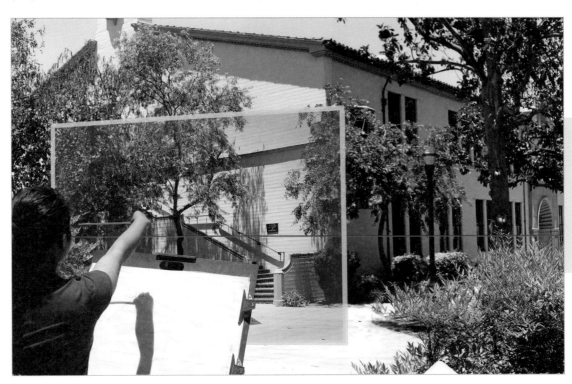

Using a chopstick for angles and exact measurements, we will make extensive use of the picture plane and follow a logical, step-by-step progression to achieve an accurate interpretation of the building.

1 Start with a thumbnail sketch. This is a helpful reference throughout the drawing process, and it provides the artist with more knowledge of the subject before beginning the main drawing. I suggest using a red pencil for eye level, both on the thumbnail sketch and the main drawing. Thumbnail sketches should always be done freehand, without rulers or measuring, in about 15 minutes.

2 Once eye level is identified, determine its placement on the paper. (It's usually about a quarter of the way up from the bottom of the page, as there is more architecture above eye level than below it.) Use actual sight-size measuring, meaning the actual size you measure with a chopstick on the building is the same measurement you put on the paper. Start with a measurement on the corner of the building closest to you; measure from eye level up to the top corner of the building (purple arrow) and then from eye level down to the bottom corner. Apply the exact measurement of the front corner of the building from eye level to the roofline to the drawing. Sight-size measuring is a very easy and logical way to obtain accurate measurements and angles for this type of drawing.

3 Use a chopstick to quickly check measurements and mark your paper, and use a ruler to achieve accurate sketched lines.

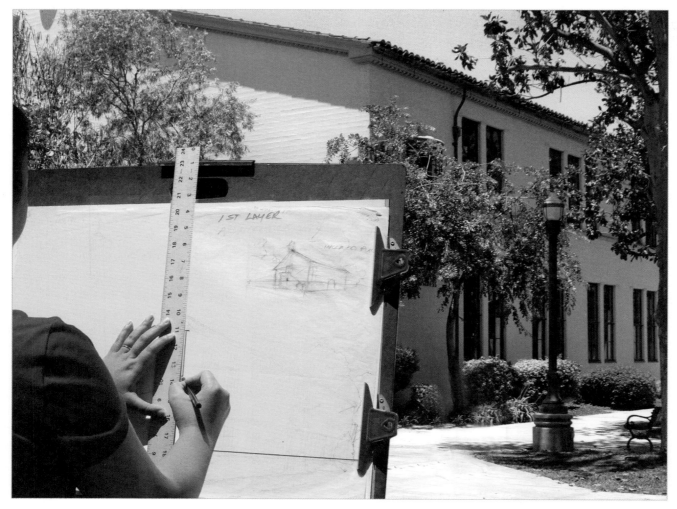

4 The next step is to ascertain the width of the front face of the building. Use the edge of the drawing board as a consistent location for your hand with the chopstick as you keep your arm straight.

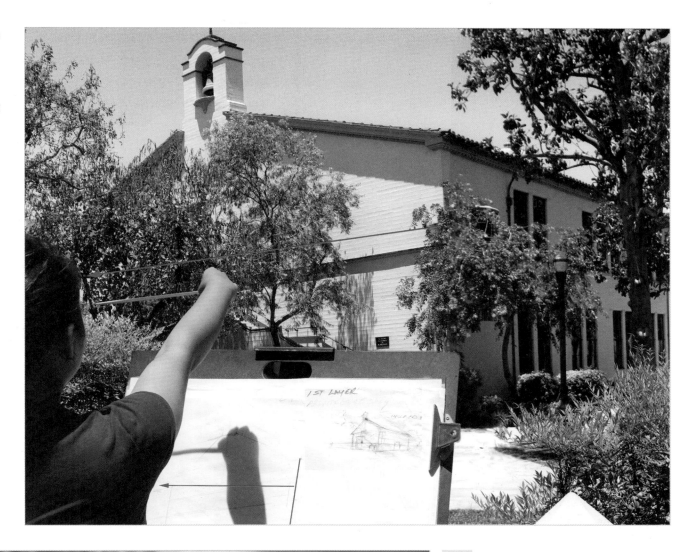

5 Apply the same measurement of the width of the front of the building to the drawing. Make a mark on the page where the location of the far corner of the building will be. When using the chopstick for angles and measurements, it is a good idea to use your nondrawing hand, as it is much easier to measure and make marks at the same time, without changing hands. Draw in the far corner, above and below eye level before moving on.

Note: The finished sketch is "ghosted" onto this image to more easily demonstrate the action.

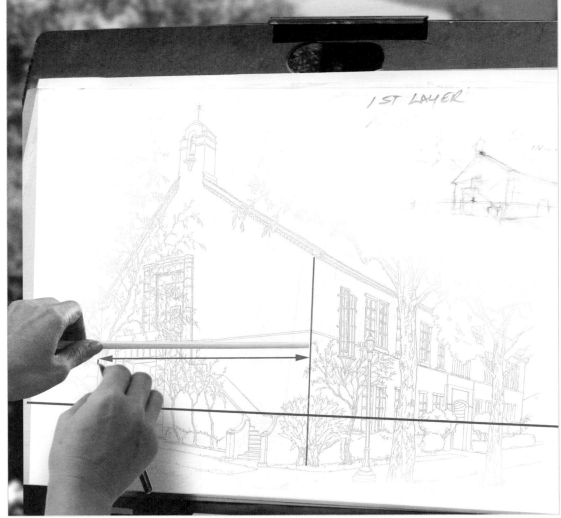

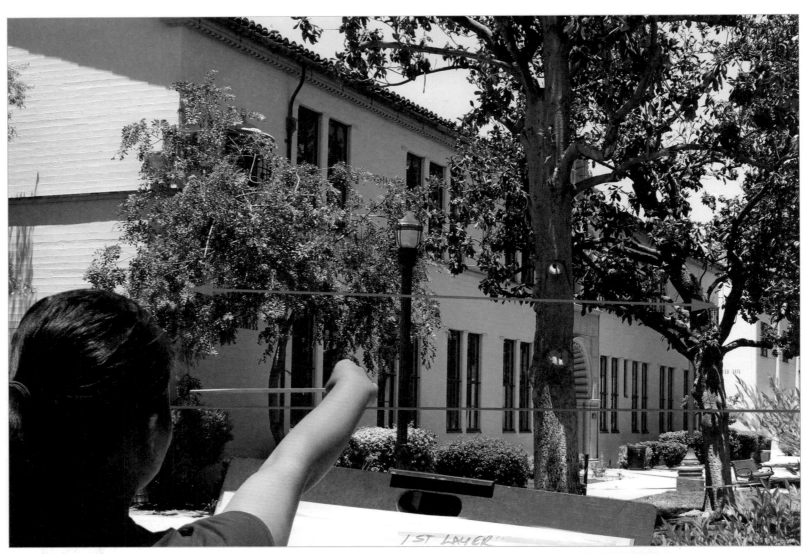

6 Now it's time to add the right side of the building. Start with the end of the chopstick on the nearest corner, which has already been drawn, and measure to the far end of the building.

7 Establish the length of the building and mark your paper. Measure the height of the building's end above and then below eye level. Remember this step; if you only measure the entire height of the wall, including both above and below eye level, you can't be certain where to locate eye level on the line.

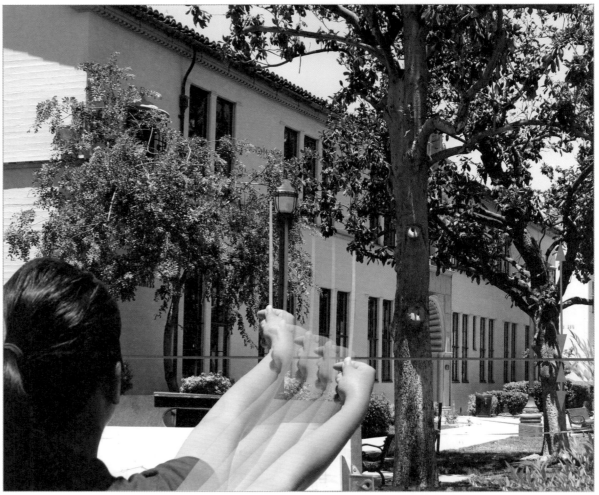

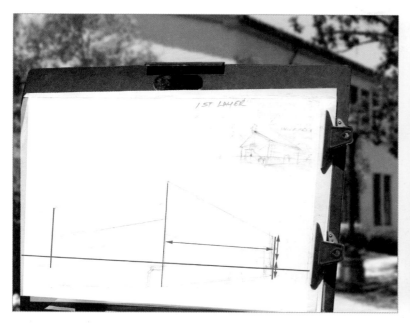

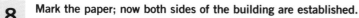

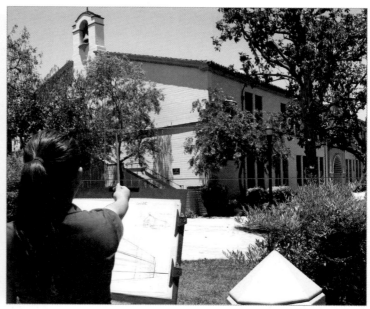

8 Mark the paper; now both sides of the building are established.

9 In order to ascertain the pitch of the roof, measure laterally from the nearest corner of the building to the vertical-axis location of the roof. You can then establish the height of the roof in that lateral location from eye level.

10 Once the rooflines are established, the bell tower can be constructed by finding the midline of the structure. Extend lines from each corner of the vertical edges that establish the height of the walls; those lines form an "X" (shown here in green), dividing the wall into perspective halves. The middle of the "X" is the location of the midline of the structure. At this point, a vertical measurement with the chopstick from eye level will locate the top of the building.

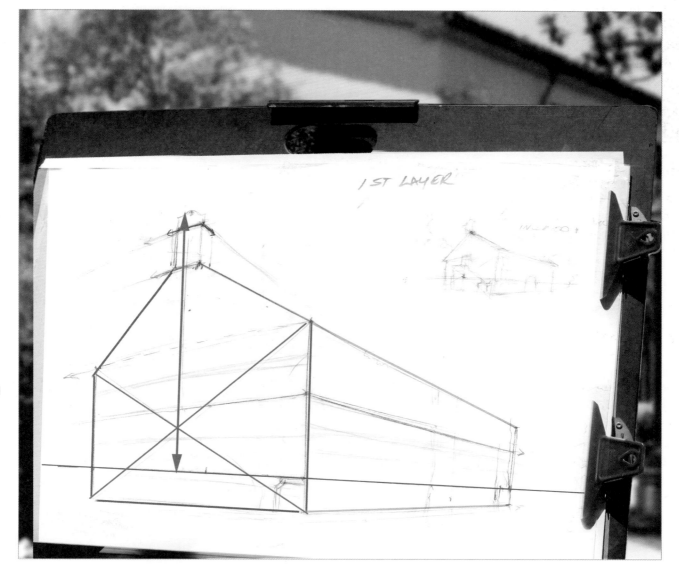

11 Check the roof angle with the chopstick.

12 After all of the measurements are finished on the first layer, add a second layer of tracing paper to refine the freehand sketch, finishing the windows, doors, trees, sidewalks, and building details.

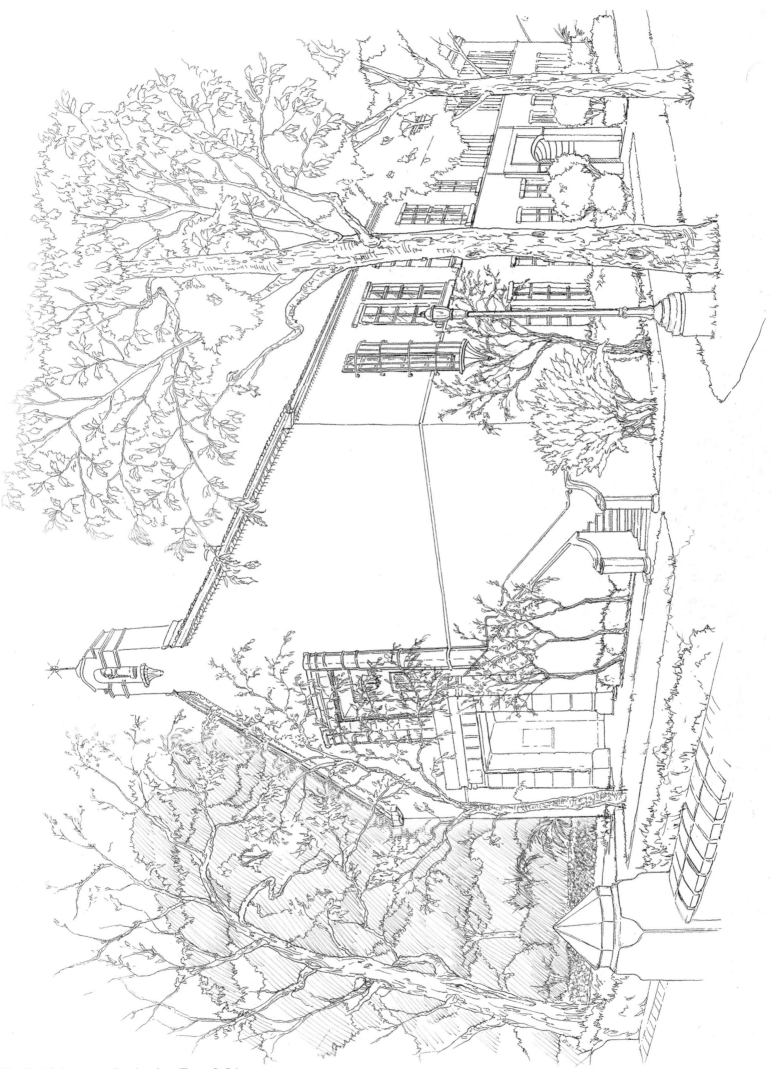

The final ink perspective drawing. Time: 6–8 hours.

Inclined Planes

Inclined planes are parallel-edged planes that are neither horizontal nor vertical to the picture plane, but rather, they are angled to it. Examples of inclined planes include staircases, elevated ramps, and angled rooftops.

These parallel-edged planes have their own point of convergence, called a trace point. These trace points rise either above or below eye level, depending on the direction that the inclined plane slants away from the picture plane. One of the rules that governs inclined planes is that parallel edges that incline away from a set of parallel and perpendicular planes (that are parallel to the picture plane) converge to a trace point that is directly vertical to the vanishing point on that side.

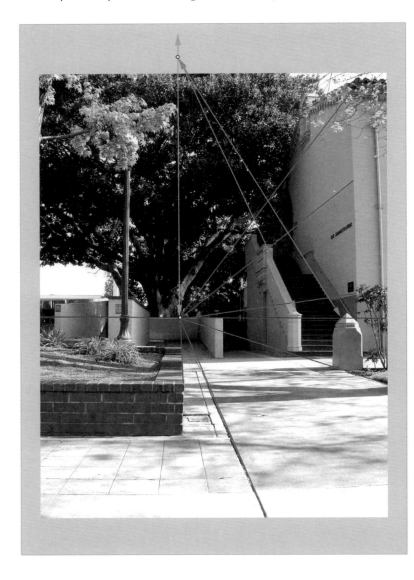

◄ Inclined planes are angled structures, such as stairways and rooflines, that don't follow the same perspective rules as structural walls parallel to the picture plane. However, they do have their own set of rules and logic. One rule seen here is that the parallel edges of the inclined plane (in this case, a staircase) converge to a trace point directly above the vanishing point.

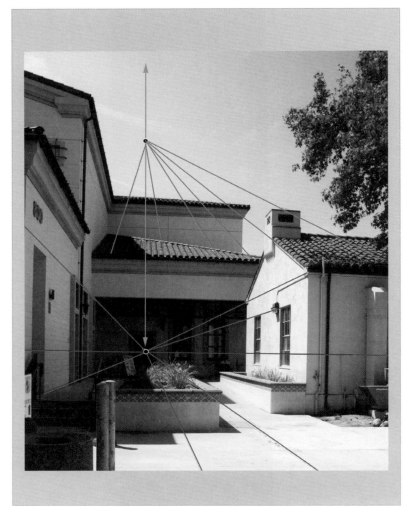

► In this example we can see that when a rooftop is angled away from the picture plane, the parallel edges of that roof converge to a trace point directly above the vanishing point for the buildings, which is always on eye level.

Aerial Perspective

The rules for this type of perspective were also discovered during the Renaissance (usually attributed to Leonardo da Vinci) and state that as objects move away from the viewer, they become softer and lighter in color and value. Da Vinci called this phenomenon the perspective of disappearance. We know now that as the distance of an object increases, more and more atmosphere comes between the viewer and the object, causing the distant object or structure to appear bluish in color.

Aerial, or atmospheric, perspective occurs as objects that are the same in color and value become muted as they move away from the viewer. As the distance of an object increases, it becomes somewhat softer and less distinct because of the atmosphere that comes between it and the viewer; the greater the distance, the greater the reduction in contrast and detail. This explains why mountains in the distance appear bluish during daylight hours. An artist can suggest atmospheric perspective by varying the line weight from the back to the front, with lighter receding lines and darker approaching lines. This same theory works with value in tonal drawings, as well as changes in value and intensity in color drawing and painting.

YOUR HOMEWORK

Create a one- or two-point perspective drawing from observation anywhere in your home. The larger and more interesting the space the better, although I have seen some very good bathroom drawings!

Start with a small thumbnail sketch of the space, understanding from the outset where your eye level is within the room, if it will be a one-point perspective drawing, and where the vanishing point is.

Sketch lightly at first, using a pencil or chopstick for measuring and angles, and refine your final drawing with the surrounding details of the room, such as houseplants, bookcases, paintings and photographs, lamps, etc.

Closing Words

The skills and techniques you have learned in this book will offer you a solid foundation upon which to build. The rest is up to you! Practice every day, even when you don't feel like it, and don't neglect the "boring" stuff. With time, you'll improve your skills, develop your own style, and grow immensely as an artist. Happy drawing!

About the Author

Jim Dowdalls received his bachelor's degree in drawing and painting, as well as his master's degree in medical illustration, from California State University, Long Beach (CSULB). He also attended the Skowhegan School of Art. Jim is currently Chair of the Art Department at Fullerton College in Fullerton, California, where he teaches representational drawing, life drawing, and illustration. He also teaches two medical illustration courses at CSULB. Jim is an accomplished medical illustrator, working with healthcare-industry clients for more than 25 years. His illustrations have won numerous awards from the Society of Illustrators and the Association of Medical Illustrators. He has created illustrations for some of the top pharmaceutical and medical product corporations, international advertising agencies, and periodicals in the United States and abroad.

Acknowledgments

I would like to thank Stephanie Meissner and Rebecca Razo at Walter Foster Publishing for selecting me to write this book, giving me the freedom to write the book I envisioned, and for their patience and guidance in editing it. I would also like to thank Polly Hung and Darren Hostetter for lending a hand whenever I was in need of one. Thank you to all my colleagues, at numerous schools throughout the last 25 years, for your mentoring and wisdom—the words of many of you are in this book. Most importantly, thank you to all of my wonderful students, whom it has been such a pleasure to know. If I neglected to include or acknowledge your work in this publication, please forgive me. This book is really about your dedication, hard work, and incredible talent.

—Jim Dowdalls

Index